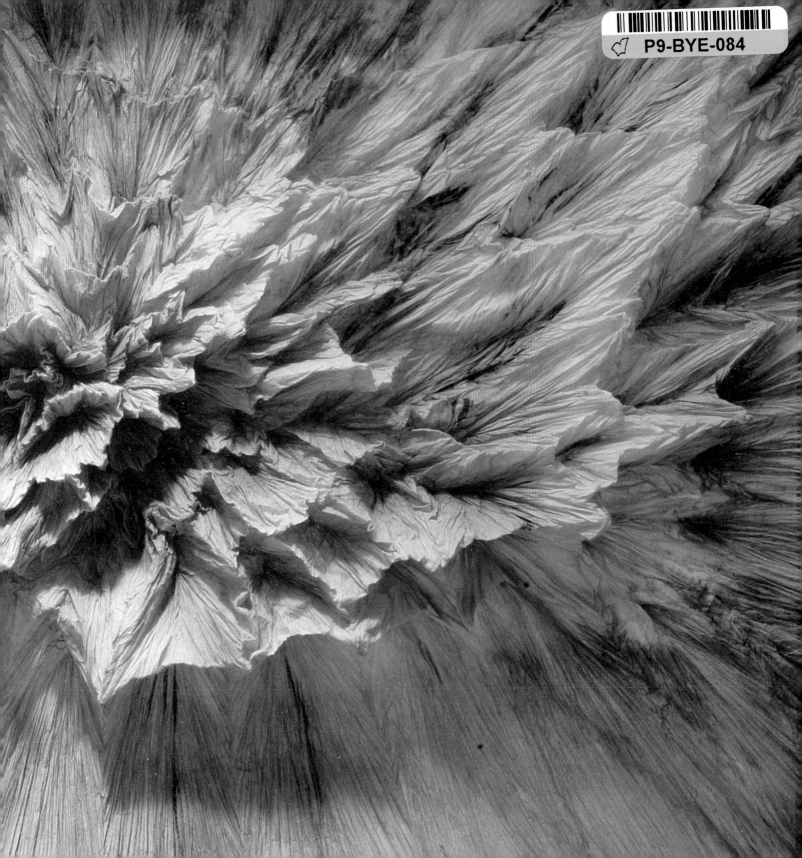

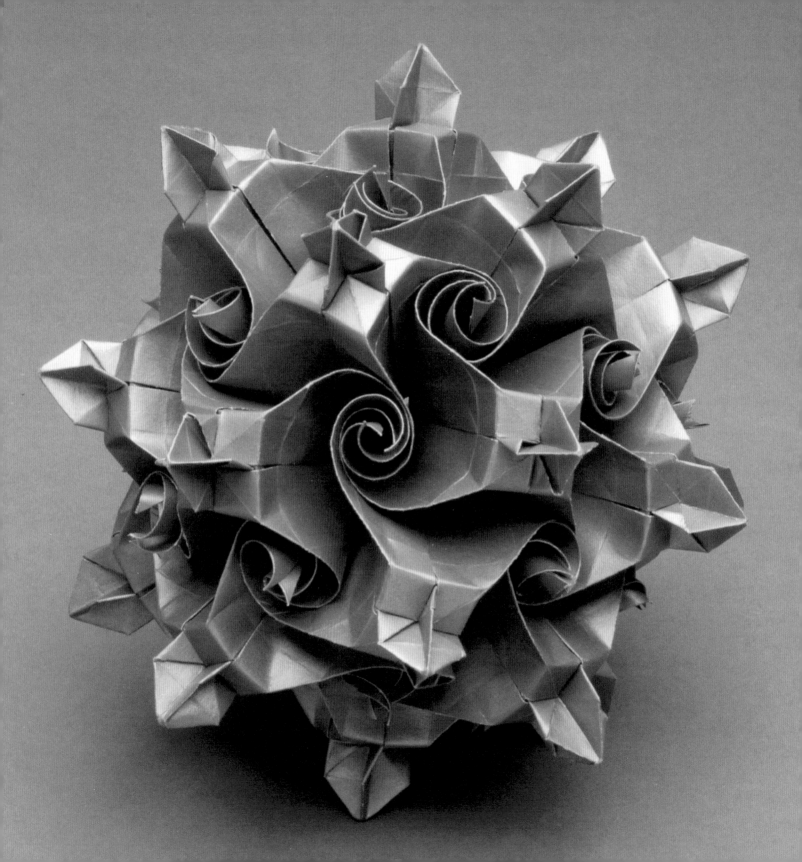

FOLDING PAPER

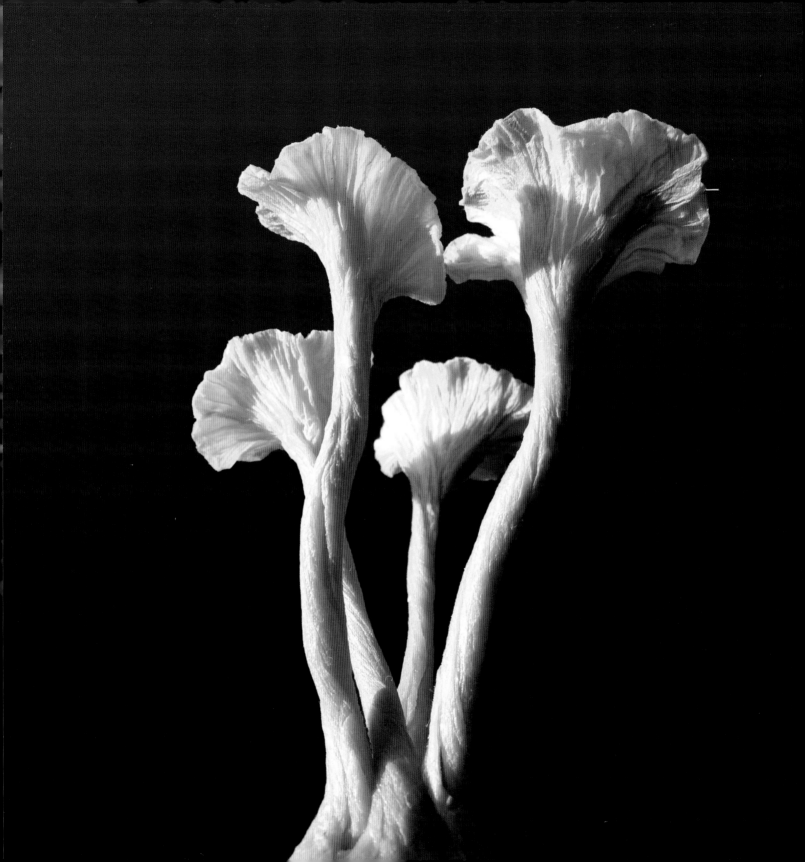

FOLDING PAPER

THE INFINITE POSSIBILITIES OF ORIGAMI

by Meher McArthur + Robert J. Lang

TUTTLE Publishing

Tokyo | Rutland, Vermont | Singapore

The Tuttle Story: "Books to Span the East and West"

Most people are surprised to learn that the world's largest publisher of books on Asia had its humble beginnings in the tiny American state of Vermont. The company's founder, Charles E. Tuttle, belonged to a New England family steeped in publishing. And his first love was naturally books—especially old and rare editions.

Immediately after WW II, serving in Tokyo under General Douglas MacArthur, Tuttle was tasked with reviving the Japanese publishing industry. He later founded the Charles E. Tuttle Publishing Company, which thrives today as one of the world's leading independent publishers.

Though a westerner, Tuttle was hugely instrumental in bringing a knowledge of Japan and Asia to a world hungry for information about the East. By the time of his death in 1993, Tuttle had published over 6,000 books on Asian culture, history and art—a legacy honored by the Japanese emperor with the "Order of the Sacred Treasure," the highest tribute Japan can bestow upon a non-Japanese.

With a backlist of 1,500 titles, Tuttle Publishing is more active today than at any time in its past—inspired by Charles Tuttle's core mission to publish fine books to span the East and West and provide a greater understanding of each.

Published by Tuttle Publishing, an imprint of Periplus Editions (HK) Ltd.
www.tuttlepublishing.com

Folding Paper: The Infinite Possibilities of Origami is curated by Meher McArthur and is organized by International Arts & Artists, Washington, D.C.

EXHIBITION DATES

Japanese American National Museum, Los Angeles, CA
March 10–August 26, 2012

Thorne-Sagendorph Art Gallery of Keene State College, Keene, NH
October 14–December 9, 2012

Leigh Yawkey Woodson Art Museum, Wausau, WI
January 26–August 26, 2013

Crocker Art Museum, Sacramento, CA
June 22–September 29, 2013

Oregon Historical Society, Portland, OR
October 19, 2013–January 11, 2014

Peoria Riverfront Museum, Peoria, IL
January 31–April 27, 2014

Bellevue Arts Museum, Bellevue, WA
May 29–September 4, 2014

Center for the Arts of Bonita Springs, Bonita Springs, FL
October 10, 2014–January 4, 2015

Brigham Young University Museum of Art, Provo, UT
January 29–June 20, 2015

Boise Art Museum, Boise, ID
October 24, 2015–January 17, 2016

Editor and Exhibition Manager: **Margalit Monroe**, IA&A Traveling Exhibitions

Registrar: **Elizabeth Wilson**, IA&A Traveling Exhibitions

Editor: **Chris Sheppard**

Design: **Simon Fong**, IA&A Design Studio

Photography: **Norman Sugimoto**

Book jacket image: *03M (Partial Shell)*, Richard Sweeney (British), UK, 2010, wet-folded watercolor paper. Photo courtesy of the artist

Frontispiece: *Mosaic Twirl*, Krystyna and Wojtek Burczyk (Polish), Poland, 2007, 24 pieces of metallic paper

Page 2: *Clitocybe*, Vincent Floderer (French), France, 2011, two-ply paper napkins, yellow Indian ink, beeswax. Photo courtesy of the artist

Last page: *Decorative Lid #3*, Arnold Tubis (American), USA, 2010, one square of duo-colored mulberry paper, black on one side and red on the other

ISBN: 978-0-8048-4338-6

Library of Congress cataloging in process.

DISTRIBUTED BY

North America, Latin America & Europe
Tuttle Publishing
364 Innovation Drive
North Clarendon, VT 05759-9436 U.S.A.
Tel: (802) 773-8930; Fax: (802) 773-6993
info@tuttlepublishing.com | www.tuttlepublishing.com

Japan
Tuttle Publishing
Yaekari Building, 3rd Floor
5-4-12 Osaki, Shinagawa-ku
Tokyo 141 0032
Tel: (81) 3 5437-0171; Fax: (81) 3 5437-0755
sales@tuttle.co.jp | www.tuttle.co.jp

Asia Pacific
Berkeley Books Pte. Ltd.
61 Tai Seng Avenue #02-12
Singapore 534167
Tel: (65) 6280-1330; Fax: (65) 6280-6290
inquiries@periplus.com.sg | www.periplus.com

17 16 15 14 13 05 04 03 02 01

Printed in Hong Kong 1303EP

TUTTLE PUBLISHING® is a registered trademark of Tuttle Publishing, a division of Periplus Editions (HK) Ltd.

"To most, the real beauty of origami lies in its simplicity, allowing everyone to create their interpretation of the world in paper."

VANESSA GOULD Director, *Between the Folds*

Frog on a Leaf
Bernie Peyton
(American), USA,
2007, leaf paper:
one rectangular
sheet of Fabriano
backed with
Mango; frog: one
square sheet
of back-coated
Shikibu Gampi Shi;
armature: wood,
acrylic, nylon
thread, magnets
Photo by Robert
Bloomberg

Between the Folds (2010, Green Fuse Films/PBS, USA) is a documentary film exploring connections between art, science and creativity through the eyes and experiences of the world's best paper folders. The film has been broadcast in more than 40 countries and in 2010 was the recipient of a George Foster Peabody Award.

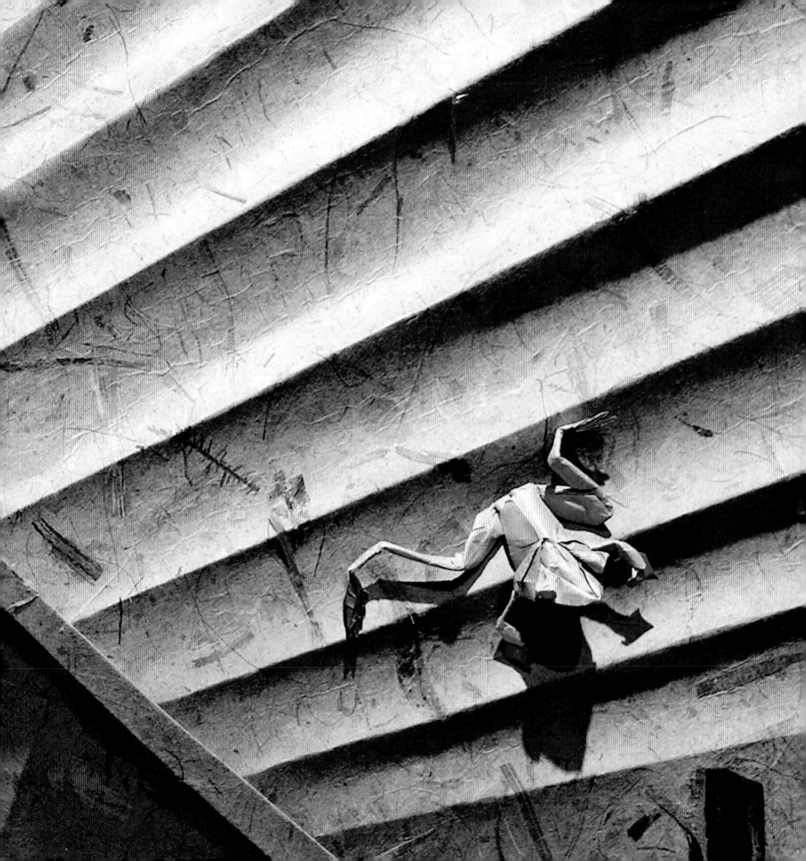

INTRODUCTION

MEHER McARTHUR Exhibition Curator

I first encountered origami as a child. In the early 1970s when my father was a professor in Scotland, two of his Japanese students gave me a tiny doll folded out of ornately decorated paper. I couldn't imagine how it was made, but shortly afterwards my parents bought me an origami instruction book by Robert Harbin, a British magician who had learned origami from folders such as Japanese master, Akira Yoshizawa. Now, I too knew the secrets of Japanese paper folding—as did more and more children and adults throughout Europe and the United States. Japanese paper folding became the subject of numerous books and television programs, schools were teaching thousands of Western children how to fold paper squares into boxes, birds, and boats, and the word origami officially entered the English language.

Nearly 40 years later, what was once considered a children's craft and an artistic pastime for nimble-fingered adults has now developed beyond the realm of craft and hobby. At the beginning of the twenty-first century, origami has evolved into a highly sophisticated art form practiced by outstanding artists from all over the world—artists who have chosen folded paper as their medium. As in painting, sculpture, photography and other more traditional art forms, origami is now a medium that encompasses a broad range of styles, from representational and stylized depictions of the natural world to abstract and conceptual sculptures and provocative installations that tackle complex social and political issues. A significant number of origami folders are professional artists whose work is commissioned and purchased by private collectors and sought after by museums—and not only craft museums but also institutions such as the Museum of Modern Art in New York. Some artists have been approached by major corporations to design and create origami for animated commercials, while others have worked with designers and architects to bring the aesthetics of origami to fashion, furniture and buildings, so that we can now wear, sit on, and live in works of origami. My essay "Origami: The Evolution of a New Global Art Form" explores the history of paper folding, its recent transformation into an art form, and the contribution of some of its most influential proponents.

That many of the folders who have elevated origami to its new place in the art world are not only accomplished artists but also respected mathematicians or scientists attests to the position of origami at the intersection of art, mathematics and science. The inherently mathematical nature of origami, with its folds, angles, and lines has greatly appealed to mathematicians who relish the challenge of transforming a flat plane into a particular three-dimensional form or an elaborately patterned surface. Figuring out how to fold a square of paper—with no cuts or glue—into beetles, deer, dragons, and other elaborate forms has become a passionate—and sometimes competitive—intellectual pursuit for many mathematically minded devotees of this art form. Equally, scientists in an increasing number of fields are applying folding principles to their investigations of engineering conundrums and molecular mysteries. So far, origami principles have been applied to the design of solar arrays on space satellites, the development of airbags in cars, the creation of a new type of heart stent in cardiovascular surgery, and even the study of how proteins fold in the human body, an area that could provide important clues about the development and cure for many diseases. This

dynamic intersection is the subject of the essay "From Flapping Birds to Packing Circles: An Origami Journey" by Dr. Robert J. Lang, who is both a renowned origami artist and a respected physicist. He has also been invaluable as the advisor for this exhibition.

Origami has held another vital role over the last half century as a symbol of peace and hope. The Japanese have believed for centuries that folding one thousand cranes can result in the fulfillment of a wish. After World War II, the practice—and perhaps even the belief—spread beyond Japan, largely because of one Japanese girl, Sadako Sasaki, who was a victim of radiation poisoning from the atomic bomb in Hiroshima and folded cranes desperately in the hope that she would recover from leukemia. The disease claimed her, but Sadako's efforts inspired children all over Japan to advocate for peace, a campaign that is now global and symbolized by the origami crane. Since Sadako's death, after major catastrophic events, such as the 9/11 terrorist attacks in the United States in 2001 and the devastating tsunami in Japan in 2011, people all around the world fold origami cranes and send them to the victims to offer hope and

comfort. One of Sadako's cranes is included in the *Folding Paper* exhibition along with the works of 45 origami artists from 16 different countries. As the exhibition tours the U.S., this tiny folded paper prayer will serve as a powerful symbol of peace and hope.

In the last decade, several exhibitions have displayed the works of contemporary origami artists, most notably the *Masterworks of Origami* at the Mingei International Museum in San Diego, California (2003) and the *Origami Masterworks* at Hangar 7 Gallery in Salzburg, Austria (2005), both artfully curated by V'Ann Cornelius, and most recently *Origami Now!* at the Peabody Essex Museum in Salem, Massachusetts (2007–2008), co-curated by *Folding Paper* artist Michael G. LaFosse. These exhibitions helped change the perception of origami here in the United States. *Folding Paper: The Infinite Possibilities of Origami* is even more ambitious. The exhibition and this catalogue not only explore the history of origami in both Japan and Europe but also its transformation since the mid-twentieth century into a significant contemporary art form. It also acknowledges origami as a source of inspiration beyond

the art world—bringing innovation to mathematics, science, and engineering and encouraging global unity through its association with peace. The exhibition is a testament to the remarkable transformation that has occurred over the last 60 years in the hands of hundreds of paper folding artists. Their bold artistic and spiritual vision, digital dexterity, and intellectual ingenuity have transformed origami into such a refined form of artistic, scientific and spiritual expression that there seems to be nothing a square sheet of paper cannot be folded into.

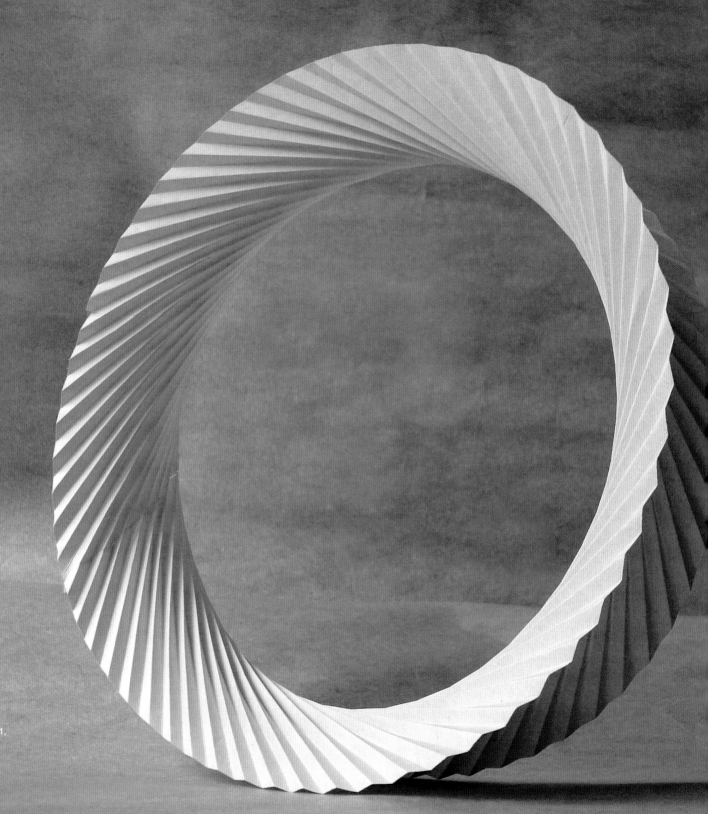

Giotto's Circle
Andrea Russo
(Italian), Italy, 2011,
paper, glue
Photo by Fabio
Giulianelli

ORIGAMI: THE EVOLUTION OF A NEW GLOBAL ART FORM

by **MEHER McARTHUR** Exhibition Curator

PART 1: THE EARLY HISTORY OF ORIGAMI

The origins of origami are obscure. It has been suggested that paper folding was first practiced in China, since paper was invented there around the second century CE and only introduced to Japan in the sixth century CE. However, the earliest paper made in both China and Japan appears to have been unsuitable for paper folding as its fibers were short, making it too brittle to withstand folding and retain a folded form. The Chinese do have a tradition of paper folding known as *zhezhi*, which includes the practice of folding objects out of paper and burning them as symbolic offerings at funerals, but there is no evidence of Chinese paper folding before 1000 CE. By this time, the Japanese were already producing high-quality paper, and it is possible they had begun folding it as part of religious rituals and within the confines of the Imperial Court.

Japanese paper folding may have roots in the spiritual and ceremonial realms. The Japanese have long believed that our world is inhabited by higher beings, or *kami*, who control nature and can take up residence in trees, rocks, rivers, and mountains. This native belief system, now known as Shinto, or the "Way of the *Kami*," stresses the importance of honoring the *kami*, and ritual purification is part of this process. For centuries, Shinto priests have marked sacred spots believed to be inhabited by *kami* with straw ropes to which are attached white paper strips called *shide* that are folded into a zigzag pattern (fig. 1). Priests also perform purification rituals using wands called *gohei* that are made up of a wooden stick and two folded white *shide*. It is not known when these folded paper strips were first used in such rituals, but they may have been the earliest type of paper folding in Japan.

Within the secular realm, some paper folding appears to have been practiced by the nobility of the Heian period (794–1185). One of the oldest types of paper folding in Japan are the *tato*, or folded paper purses, that were carried by gentlemen of this period. They were folded vertically and horizontally and sometimes contained thinner paper inside that they used to write letters or to blow their noses. The ladies of the Heian period, and particularly those who resided in the Imperial court, wrote letters and poetry in delicate, willowy calligraphy on luxurious paper that was often beautifully decorated with natural and seasonal motifs and exquisite colors and patterning. They apparently used a number of methods to fold their letters, but we know little about these, as they have not survived or been well documented.

It may also have been during the Heian period that the first creatures were folded out of paper. It is possible that the practice of decorating bottles of rice wine, or *sake*, used in weddings with folded paper butterflies dates to this period. In traditional Shinto weddings, the bride and groom are considered officially married after they have sipped wedding *sake* together, taking three sips each from three small cups. The *sake* is served from two flasks, one for the bride and one for the groom, and each flask is decorated with a paper butterfly attached to it using strings. The male butterfly, or *Ocho*, is more elaborate than the female, *Mecho* (fig. 2). It is likely that these ceremonial butterflies were not the only creatures folded in paper at this time and that the hobby of folding paper was also practiced among members of the nobility.

The tradition of paper gift-wrapping, or *tsutsumi*, has a long history in

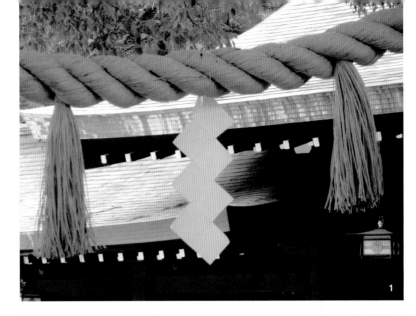

Japan. It may have begun among the courtiers of the Heian period, but an eighteenth century Japanese book about ceremonial paper folding called *Tsutsumi-no Ki* explains that this tradition was established in the Muromachi period (1333–1574), when the samurai class was ruling Japan from Kyoto. According to this text, samurai etiquette required warriors to fold wrapping paper in a certain way depending on the gift inside, and this gift wrapping etiquette was passed down from generation to generation. At some point, these folded gift wrappers were adorned with *noshi*, a small auspicious charm usually made of carefully folded red and white paper (fig. 3). *Noshi* traditionally contained a strip of dried and stretched abalone meat, or *noshita awabi*, which represented long life and good fortune, but the abalone was later replaced with a strip of yellowish paper. These folded paper gift wrappers are the ancestor of the modern *shugi*, envelopes which are usually tied with red and gold-wrapped paper strings, and are given for celebrations such as weddings, and the *kaden*, which usually feature black strings and are given at funerals. Both types of gift wrappers still typically feature a small paper *noshi* element (fig. 4, page 14).

Fig. 1
Sacred trees at the Meiji Shrine in Tokyo marked with a straw rope and folded paper strips called *shide*
Japan, 2011
Photo by Meher McArthur

Fig. 2
Male and Female Butterfly (*Ocho* and *Mecho*) Wedding Decorations
Japan, 2011, paper, string, gold leaf

Fig. 3
Auspicious Charm (*Noshi*)
Japan, c. 2011, paper, gold leaf

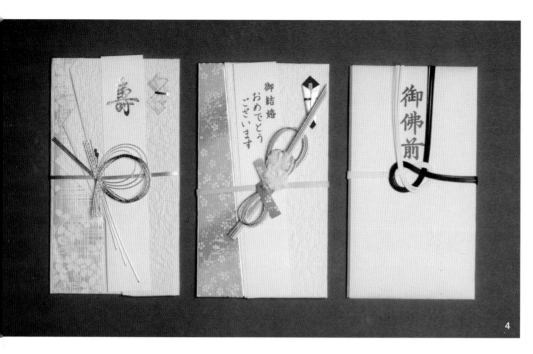

4

Fig. 4
Decorative Gift Envelopes
Japan, c. 2010, paper, string, gold leaf

Fig. 5
Reproduction of *Secret Folding Methods
for One Thousand Cranes (Hiden
Senbazuru Orikata)*
Japan, 1797 (reproduction published in
1997), woodblock printed book

5

For several more centuries, members of the nobility and ruling samurai classes, who were able to afford expensive paper, continued folding paper into gift wrappers and perhaps animal forms too. By the Edo period (1600–1868), paper became less expensive and more widely available among the general population. It was in this period that Japanese paper folding as we know it today really began to evolve, though it was still not yet called *origami*, but was known by various names, including *orikata*, *orisue*, *orimono*, and *tatamigami*. A number of references in popular literature to people folding various creatures and other forms out of paper attest to its increasing popularity. One contemporary poem refers to the folded butterflies on wedding sake bottles, so we know that this custom was certainly practiced by this time. A popular story tells of a legendary wizard, Abe no Seimei, who folds a paper bird and then uses his magical powers to transform it into a real bird which then flies away. The scene was captured in a woodblock printed image by Japan's most celebrated artist, Katsushika Hokusai (1760–1849) in one of his popular *Manga* painting manuals, in which he depicts sheets of folded paper transforming magically into egrets (fig. 6), an image that has been recreated in three-dimensional form by artists including Giang Dinh (fig. 7).

Interest in paper folding forms and techniques led to the publication of woodblock printed instructional books during this period. The oldest surviv-

Fig. 6
*Abe no Seimei
Turning Origami
into Real Birds*
Katsushika Hokusai
(1760–1849),
Japan, 1819
Courtesy of F.
Steven Kijek, photo
by Simon Fong

Fig. 7
Fly
Giang Dinh
(Vietnamese
American), USA,
2010, watercolor
paper
Photo courtesy of
the artist

ing volume was published in 1797 and titled *Hiden Senbazuru Orikata*, which can be translated as *Secret Folding Methods for One Thousand Cranes* (fig. 5, page 14). In Japan, the crane symbolizes long life and good fortune, and there is an old belief that if someone folds one thousand cranes, they will be granted a wish. In particular, the folding of cranes was related to wishes for long and happy marriages, and garlands made up of one thousand cranes were made as wedding gifts. Folding paper cranes was clearly a popular pursuit in the Edo period, because the entire volume is devoted to explaining different ways to fold not just a simple crane form, but multiple crane forms—including a mother crane with two babies—out of a single sheet of paper. These *renzuru*, or connected cranes, are made by cutting the paper, a practice that appears to have been common for more complex traditional origami forms. The line drawings illustrating the various crane configurations are accompanied by explanations of how to fold and cut the paper to create each form. Few copies of the original volumes exist, but it was reprinted in 1997 to meet the demand of origami enthusiasts.

Another volume that was published in the nineteenth century is the classic work called *Kayaragusa* (formerly known as *Kan no Mado*). The *Kayaragusa* represents two chapters of a larger encyclopedic work compiled in the mid-nineteenth century called *Naniyara Kayaragusa, or A Collection of This, That and the Other*, by the

scholar Kazuyuki Adachi, about whom very little is known. The *Kayaragusa* sections are devoted to paper folding and contain drawings and diagrams showing how to fold forms as diverse as dancing figures, irises, persimmons, wrappers, and wedding butterflies. Few copies of the original have survived, but it was reprinted in the U.S. in 1961 and is a valuable source of information about traditional Japanese folded paper designs.

It seems that by the nineteenth century in Japan there was quite an elaborate repertoire of folded paper designs available to the folding enthusiast. What is surprising to origami enthusiasts today is that while the Japanese were folding paper irises, cranes, dancing monkeys, and persimmons for fun and for special occasions, thousands of miles away in Europe, another tradition of paper folding was also evolving, most notably in Spain and Germany.

As in Japan and China, European paper folding was not regarded highly enough to merit documentation, so it is unclear when this practice first began, but it was certainly fairly well developed by the nineteenth century. As we have noted, paper was invented in China sometime around the second century CE, and it took another one thousand years or so to reach Europe. Arabs learned paper making from the Chinese around the eighth century CE and the Moors brought paper to Spain around the eleventh century and started producing it in the country sometime thereafter.

Over the ensuing centuries in both Spain and Germany, which first began making paper in the fifteenth century, paper folding appears to have been practiced to a limited degree. As in Japan and China, some of the earliest European paper folding was also done within a ceremonial context. The custom of folding baptismal certificates seems to have been popular in central Europe in the seventeenth and eighteenth centuries and may have been practiced as early as the sixteenth century. All four corners of these square certificates were folded into the center to form a smaller square, and then the corners of that square were then folded into the center again to form a small square that opens up to resemble a four-pointed star or cross.

By the nineteenth century, several popular forms were folded out of paper, the Spanish *pajarita* (fig. 12) being the best known of *papiroflexia*—as paper folding is known in Spanish—but other forms, such as hats, boats and houses were also known and folded in Europe. In the early nineteenth century, Friedrich Fröbel (1782–1852), a German educator who established the kindergarten system in 1837, further developed European paper folding. Fröbel was an avid paper folder and realized that paper folding could help children develop fine motor skills. He incorporated *papierfalten* into the kindergarten curriculum as one of the most important "Occupations" that the children were required to learn. Some of his advanced forms, such as the star, the Fröbelstern (fig. 13), are now German

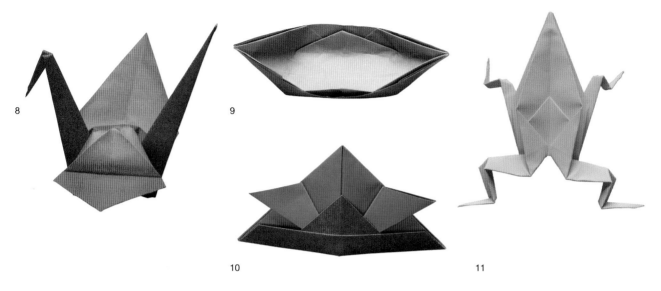

8

9

10

11

Figs. 8–11: Traditional Japanese forms

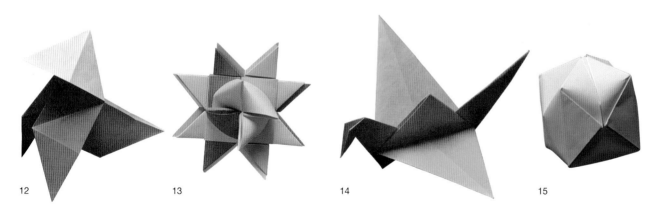

12

13

14

15

Figs. 12–13: European forms

Figs. 14–15: Forms with uncertain origins

Objects in figs. 8–13 and 15 created by Ruthie Kitagawa (Japanese American)

Fig. 8
Traditional Japanese Folded Paper Crane
USA, 2012, paper

Fig. 9
Traditional Japanese Folded Boat
USA, 2011, paper

Fig. 10
Traditional Japanese Folded Samurai Helmet
USA, 2011, paper

Fig. 11
Traditional Japanese Folded Frog
USA, 2011, paper

Fig. 12
Traditional Spanish Folded Paper Bird (*Pajarita*)
USA, 2011, paper

Fig. 13
Traditional German Folded Paper Star (*Fröbelstern*)
USA, 2011, paper

Fig. 14
Traditional Folded Flapping Bird
Meher McArthur (British/American), Japan, 2011, paper

Fig. 15
Traditional Folded Balloon/Water Bomb
USA, 2011, paper

paper folding standards, and his education and paper folding legacies are celebrated today in the Friedrich Fröbel Museum in Bad Blankenburg in central Germany.

In the late nineteenth century, Japanese society went through a major upheaval. Military leaders, or shoguns, had ruled the country since the late twelfth century, and from the mid-seventeenth century had been largely closed to the outside world. In 1868, the weakening military regime was toppled by supporters of the emperor, who was then restored to political power. The new government opened Japan up to Western influence and adopted many practices from the United States and Europe, including the German education system. In the late nineteenth century, Japanese children were enrolled in the country's first kindergartens, which were based on the German models and included European paper folding. Japanese teachers no doubt incorporated their own traditional paper folding designs into the curriculum. It was in the Japanese kindergarten classrooms of the late nineteenth century that the European and Japanese paper folding traditions converged (fig. 16). It was at this point that the Japanese term origami (meaning "folding/folded paper" and probably inspired by the German term papierfalten) became the standard Japanese name for this practice.

Many of the forms that are now considered part of the traditional origami repertoire, such as boats, boxes and hats, existed in both Europe and Asia prior to the nineteenth century and seem to have been invented independently (see page 17). Certain forms such as the pajarita, the traditional windmill, and a simple house form seem to have been European inventions that entered Japanese origami via the kindergarten system. Other forms— such as cranes, irises, frogs, and dragonflies, all described and illustrated in the woodblock printed books of the Edo period—are part of the Japanese traditional repertoire. However, there are certain forms that remain controversial, such as the balloon or water bomb form that is one of the staples of origami folders today. Japanese origami historian, Koshiro Hatori, who is also an origami artist featured in this exhibition, has suggested that the balloon may be a European form that dates back to the early seventeenth century. Hatori has also compared early European and Japanese models and concluded that while early European models, including baptismal certificates, were typically paper squares with creases that are either square grids or diagonals, early Japanese models were made from sheets of various shapes, often had more complex folding and were often cut. Since some origami purists today insist that true origami is made from squares of paper with no cuts and no glue, such a conclusion is laden with irony.

"Origami is a metamorphic art form."

MICHAEL G. LaFOSSE
Excerpt from *Between the Folds*

Fig. 16
*Children Making
Origami Crane*
from *Customs of
Children* series
Shuntei Miyagawa
(1873–1914),
Japan, 1896
Courtesy of
Margalit Monroe,
photo by Simon
Fong

PART II: THE MODERNIZATION OF ORIGAMI IN THE TWENTIETH CENTURY

In the early decades of the twentieth century, most practitioners of origami in Japan were probably children. Families folded paper together and occasionally created new forms to amuse and entertain their children. Origami was associated with craft and children's play, relegated to the classroom, and had no status in the world of art. However, in the mid-twentieth century, a farmer's son, Akira Yoshizawa (1911–2005), became the country's first true "origami artist," and is credited with elevating origami to a fine art form. Yoshizawa worked in a factory as a teenager but was so fascinated by paper folding that he left his job in his late twenties to dedicate his life to origami. For approximately 20 years he lived in poverty while perfecting his craft. He developed thousands of new designs and pioneered the art of "wet-folding," a technique that allows for the sculptural modeling of details (fig. 17). By the 1950s, his work was featured in numerous publications, and in 1954 his book *Atarashi Origami Geijutsu* (*New Origami Art*), propelled him to fame. In this book, Yoshizawa introduced a system of notation for origami folds which is made up mainly of lines and arrows and requires no words of explanation (see page 64). A version of this system has since become the worldwide standard and international visual language for paper folding instruction. The same year, he founded the International Origami Center in Tokyo and began holding origami exhibitions overseas, serving as a cultural ambassador for Japan. Yoshizawa wrote 17 more books on origami and in 1983 Emperor Hirohito awarded him the Order of the Rising Sun, a profound honor and a highly prestigious decoration. Yoshizawa's dedication not only modernized origami but helped transform it into a global art form.

As Yoshizawa was elevating the art of origami in Japan, an interest in paper folding was also growing slowly in other parts of the world, most notably the U.S., Europe and South America. In 1928, the first English-language book devoted solely to recreational paper folding, *Fun with Paperfolding*, was published in the U.S. The book, written by two magicians, William D. Murray and Francis J. Rigney, taught forms such as boxes, fish, houses, and the flapping bird (fig. 14, page 17). The book sparked the interest of an American woman, Lillian Oppenheimer (1898–1992), who used it to help entertain her sick daughter during hours spent in doctors' waiting rooms. Many years later in the early 1950s, Oppenheimer attended an adult education class in paper folding in New York with a German teacher, Emily Rosenthal, who had learned paper folding while training as a teacher under the Fröbel method of child education. Oppenheimer joined forces with another enthusiastic student, Frieda Lourie, with whom she later founded the Origami Center in New York in 1958. The Center not only provided origami information and education but also helped popularize the term "origami" in the English-speaking world. Oppenheimer was also close to Florence Temko (1921–2009), another origami pioneer who designed numerous forms, wrote many books about origami and whose work is also featured in this exhibition. Oppenheimer and her community of origami folders and educators inspired many other folders in the U.S.

In Europe, Robert Harbin and Gershon Legman paralleled Oppenheimer's work in the U.S. Harbin (1909–1978), a well respected magician and illusionist, was instrumental in popularizing origami in the United Kingdom. His 1956 book *Paper Magic* was welcomed by many enthusi-

asts including Oppenheimer. His research into paper folding led him to the work of Yoshizawa in Japan, and he studied many of Yoshizawa's designs and models. Along with American folder Samuel Randlett (b. 1930), Harbin expanded Yoshizawa's system of fold notation, so that it is now widely known as the Yoshizawa-Randlett-Harbin system. In the 1960s and 1970s, Harbin went on to write several subsequent books on origami and promoted the art form on many popular television programs in the U.K.

At the same time, in southern France, Gershon Legman (1917–1999), an American cultural critic and folklorist, was also championing paper folding. He too had discovered the origami works of Yoshizawa, and in 1955 he organized an exhibition of Yoshizawa's origami at the Stedelijk Museum in Amsterdam, the first official introduction of the Japanese master's work to Europe. The exhibition was enthusiastically received, and a few years later, working with Lillian Oppenheimer, Legman sent many of the pieces from the Amsterdam exhibition to New York where they were exhibited at the Cooper Union Museum in 1959 and later at the Japan Center. This last exhibition ended in

Fig. 17
Akira Yoshizawa (1911–2005, Japanese) and his design
Photo courtesy of Mrs. Kiyo Yoshizawa, with thanks to the Paper Museum, Tokyo, Japan

disaster and embarrassment for Oppenheimer. The origami models were displayed without glass or security, and visitors took every one of them home as souvenirs!

Another important contribution to the globalization of origami in the twentieth century came from Spain. The celebrated writer and philosopher Miguel de Unamuno (1864–1936) made a hobby of paper folding, inventing a

variety of new animal constructions, many based on the flapping bird form (without a knowledge of the Japanese bird forms or origami bird base), and writing about the art form in his humorous novel *Amor y pedagogía* (*Love and Pedagogy*) in 1902. Fellow Spaniard, Vicente Solórzano Sagredo (1883–1970) was a physician with a passion for paper folding. He relocated to Argentina in the early twentieth century becoming a dentist and paper folder. He created

22

Fig. 18
Photo of Japanese school children in front of Sadako Sasaki's statue and encased offerings of origami cranes, Hiroshima Peace Memorial Park
Japan, 2011
Photo by Meher McArthur

numerous ingenious designs for human and animal figures and coined the Spanish words *papirola* (meaning "folded paper figure") and *papiroflexia* (meaning "paper folding") around 1910. Sagredo authored the most comprehensive manuals on the art in Spanish, including *Papirolas 1er Manual* (*First Manual of Folded Paper Figures*), in 1938, *Tratado de Papiroflexia Superior* (*A Treatise on Superior Paper Folding*) in 1945 and *Papiroflexia Zoomórfica* (*Zoomorphic Paper Folding*) in 1962. He hired a young Argentinean woman, Ligia Montoya (1920–1967), as an illustrator for several of his books. Montoya herself became an accomplished folder, analyst of folds and innovator in diagram notation. She is even thought to have improved upon some of Sagredo's folds and she designed a number of her own figures that were distinct from Sagredo's figures. In the 1950s, Montoya entered into communication with Gershon Legman, who had discovered the work of these sophisticated Argentinean folders, and soon she was also in touch with Lillian Oppenheimer and her works featured in the 1959 New York exhibition at the Cooper Union Museum. According to British origami historian, David Lister, it was the consolidation of a network of paper folding enthusiasts in the U.S., Europe and South America in the 1950s, and the increasing international awareness and inspiration of Yoshizawa's remarkable works that engendered the global origami movement.

Although not actually an origami artist, one more figure was crucial in the global fascination with origami in the 1950s—

Sadako Sasaki. Born in Hiroshima, Sadako was two when the atomic bomb was dropped on the city and contracted leukemia when she was 12. When she was hospitalized, one of her fellow patients told her about the Japanese belief that anyone who folds one thousand cranes would be granted a wish, so Sadako began folding cranes with the hope of recovering from her disease. Some accounts of her life say that she died before she could fold all one thousand cranes, but according to her family, she reached her goal but kept folding cranes hopefully, out of any paper she could find, even candy wrappers. Sadly, she succumbed to the disease in October 1955. Children all over Japan were so moved by her struggle that they petitioned for and raised money to build a monument in her honor at the Hiroshima Peace Memorial Park in 1958 (fig. 18). The monument is surrounded by garlands and pictures made of origami cranes sent there by children from all over Japan and symbolizes the hope for world peace. Some of Sadako's folded cranes, or *orizuru*, are on display at the Hiroshima Peace Memorial Park Museum, and one is on view in the *Folding Paper* exhibition, as a reminder of the horrors of war. Inspired by Sadako and the children of Japan, people all over the world have adopted the practice of folding cranes as symbols of peace and recovery. Now, whenever a major disaster strikes anywhere in the world, cranes are folded and sent to victims as offerings of hope. November 11, a date that represents remembrance of those who have fallen in wars around the world, has also become known as World Origami

Day in Japan, reinforcing the connection between origami and peace.

As a symbol of harmony, longevity, and prosperity, the origami crane has also provided inspiration for many artists around the world. Exquisite contemporary versions of the origami crane, like the design created by Uruguayan Roman Diaz, feature new, more naturalistic forms yet still possess the symbolic power of this elegant bird (fig. 22, page 29). More traditional in form but revolutionary in construction are the crane pieces by Japanese American artist Linda Tomoko Mihara, who specializes in the traditional *renzuru* technique of folding and cutting (but not gluing) paper to produce complex structures such as spheres and cubes made up of multiple cranes (figs. 19 and 20, pages 24 and 25). She also creates large two-dimensional images built up out of 1,001 folded and flattened cranes, a type of origami mosaic imbued with wishes for a long life and happy marriage. Israeli artist, activist, and educator Miri Golan uses not only origami cranes but the origami art form as a tool for promoting peace in her country, and teaches Israeli and Palestinian children to fold paper together in friendship. In her own oeuvre, Golan explores the theme of peace with powerful conceptual works such as *Two Books*, in which origami human figures emerge from the pages of the two sacred texts, the Torah and the Koran, and reach out to each other (fig. 21, pages 26 and 27).

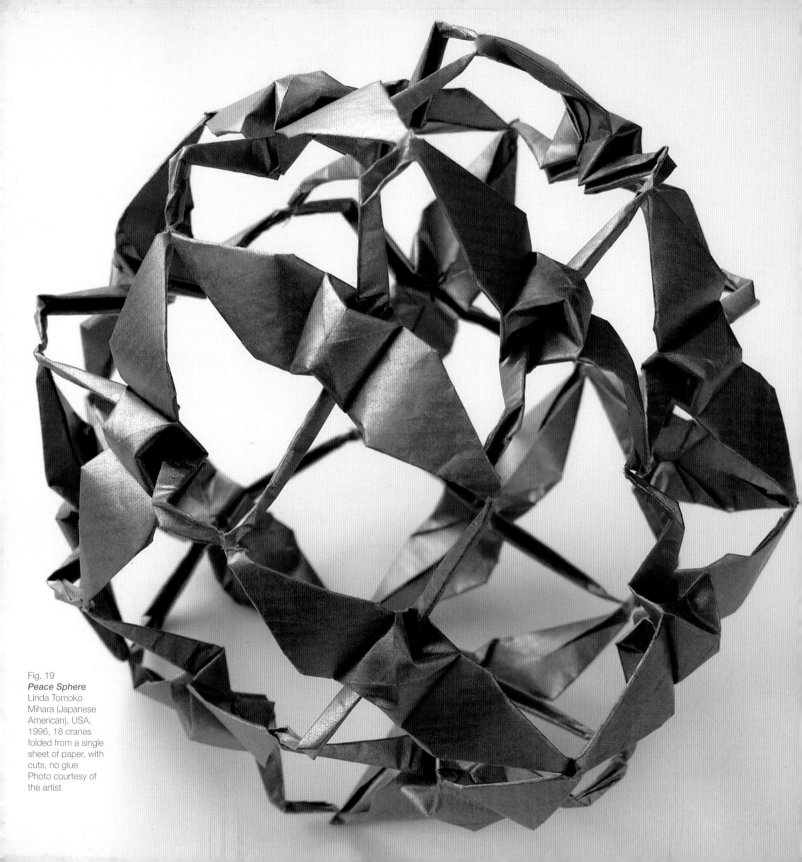

Fig. 19
Peace Sphere
Linda Tomoko
Mihara (Japanese
American), USA,
1996, 18 cranes
folded from a single
sheet of paper, with
cuts, no glue
Photo courtesy of
the artist

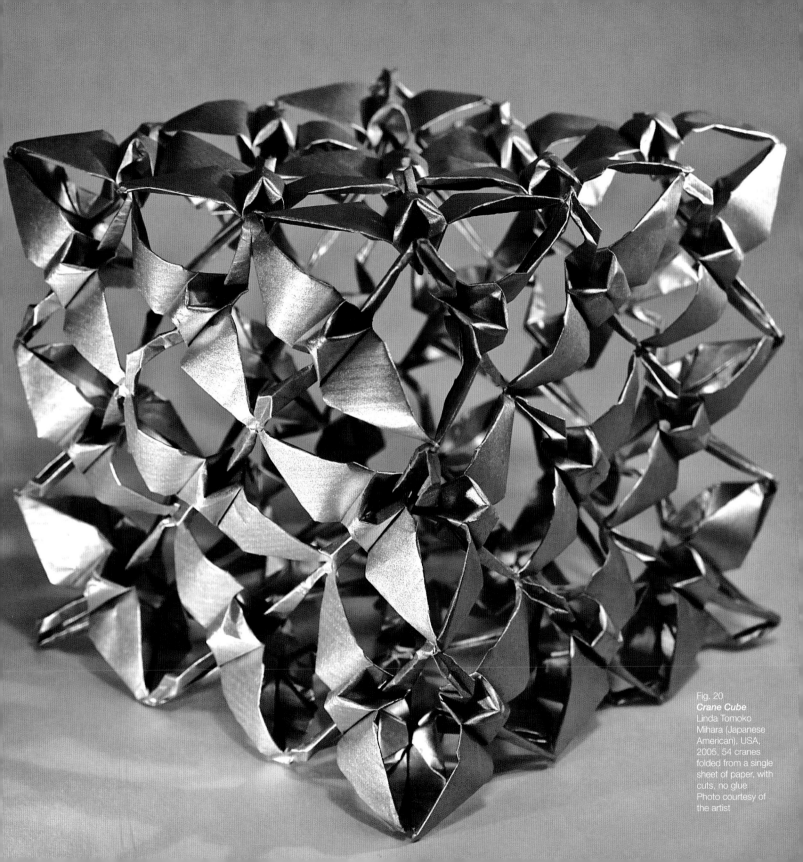

Fig. 20
Crane Cube
Linda Tomoko
Mihara (Japanese
American), USA,
2005, 54 cranes
folded from a single
sheet of paper, with
cuts, no glue
Photo courtesy of
the artist

Fig. 21
Two Books
Miri Golan (Israeli),
Israel, 2010, paper
and handmade
books
Photo by Leonid
Padrul-Kwitkowski/
Eretz Israel
Museum

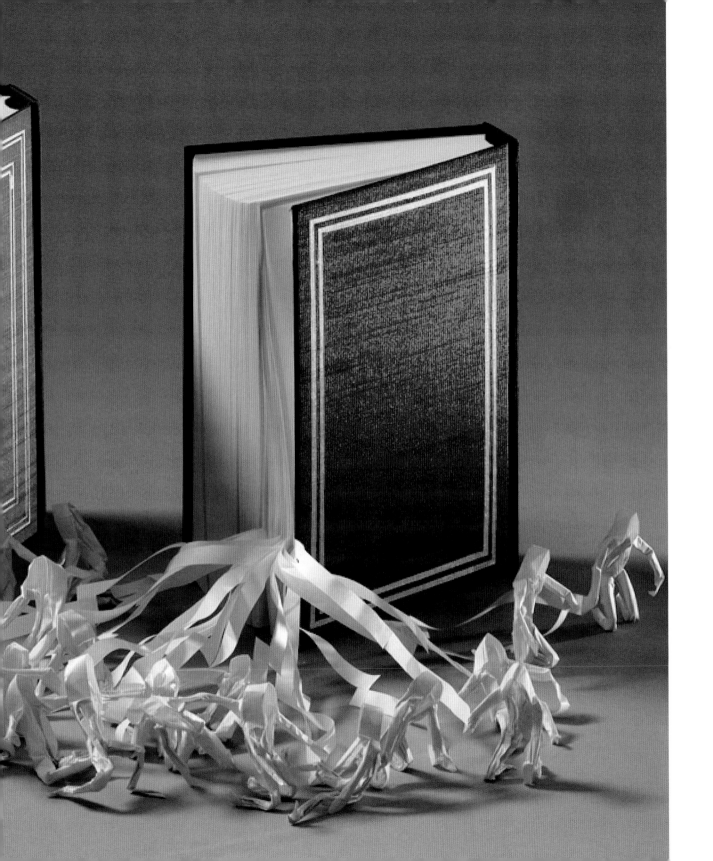

PART III: A NEW GLOBAL ART FORM

Since the 1950s, artists all over the world have been inspired to push the boundaries of traditional European paper folding and Japanese origami, resulting in the emergence of a new and unique type of sculptural art. Many contemporary origami artists have transcended the traditional flat, angular representations of animals and objects associated with conventional Western and Eastern paper folding traditions. Some began their artistic journey with common forms and found ways to fold increasingly complex and sculptural creations, while others were sculptors who discovered that folding paper presented them with a whole new world of possibilities. Over the last few decades, by experimenting with new techniques such as wet folding, curve folding and circle packing (see Robert J. Lang's essay, page 62), working with a wide variety of papers, and following their own aesthetic inclinations, paper folding artists have elevated this craft into an art form that now comprises many different styles and genres. Though often separated by continents, origami artists generally remain in close contact with each other via international origami societies and the Internet, where they often share designs and techniques with each other, a rare practice in the art world. As Lang explains in his essay, this exchange of ideas is more common in the world of science, and has had a tremendous impact on the recent evolution of the origami art form.

ANIMALS AND ANGELS:
Representations of the Natural and Supernatural Realms

Contemporary origami often falls into the category of representational forms—one or more sheets of paper folded into an animal, flower or figure from the real or supernatural realm. Artists have taken this type of origami in several directions, towards complexity, naturalism or stylization.

Complex models of natural and supernatural creatures are explored by artists such as Robert J. Lang, Brian Chan and Satoshi Kamiya, who apply a mathematical approach to folding paper figures usually out of a single square of paper with no cuts or glue. Lang, an American physicist turned full-time origami artist, uses geometry to unlock mathematical techniques that allow him to create new crease patterns, which are maps of the major folds of his designs. His computational origami has produced incredibly elaborate models of birds and insects, many of which are developed using the packing methods discussed in his essay. Although created using mathematical techniques, Lang's complex insect, animal and bird figures exhibit great elegance in their form and expression and exemplify the successful convergence of science and art (figs. 69–74, pages 71–73). Similar effects are achieved in the works of Chinese American Brian Chan, who trained in mechanical engineering and has also mastered complex origami folding. His love of nature is apparent in his insects, which, though born from elaborate mathematical folding methods, are imbued with a sense of graceful, lifelike motion (fig. 75, page 74). A keen observer of his bird and animal subjects, Uruguayan veterinarian and origami artist Roman Diaz folds models that faithfully capture the essence of these creatures. One of his most complex and powerful models depicts a crane right as it is about to take flight, with its head lowered, legs bent and wings lifted. Not only the form of the bird, but its energy and character, are naturalistically portrayed as it surges into motion (fig. 22, opposite).

Also working in the field of complex origami is Japanese artist Satoshi Kamiya, renowned for his intricate representations of fantastic creatures from both the real and imagined realms. However, unlike Lang and Chan, who calculate their folds either using a pencil and paper or computer programs, Kamiya simply imagines the forms, unfolds them in his mind, and then tries to refold them in paper. The results are dragons and dinosaurs depicted in fierce poses with mouths open and tails swinging, exuding a magical energy. A similar dynamism can be seen in the works of Victoria Serova, a Russian artist who has also applied complex origami techniques to the creation of multi-legged crustaceans and a spectacular folded version of the Russian national coat of arms (fig. 25, page 32).

Although not usually grouped with the above artists, two other folders—Hieu Tran Trung and Joel Cooper—are worth noting for their complex origami representations of our world. Tran Trung is a Vietnamese schoolteacher with a passion for origami and dinosaurs. Just as paleontologists piece together the vertebrae and other bones of an

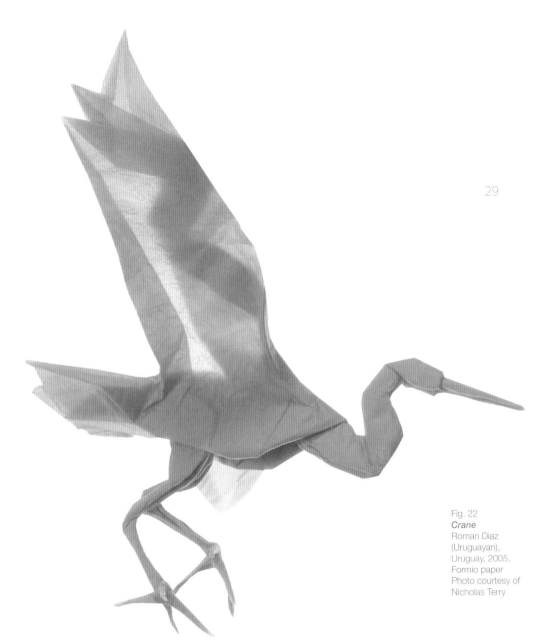

Fig. 22
Crane
Roman Diaz
(Uruguayan),
Uruguay, 2005,
Formio paper
Photo courtesy of
Nicholas Terry

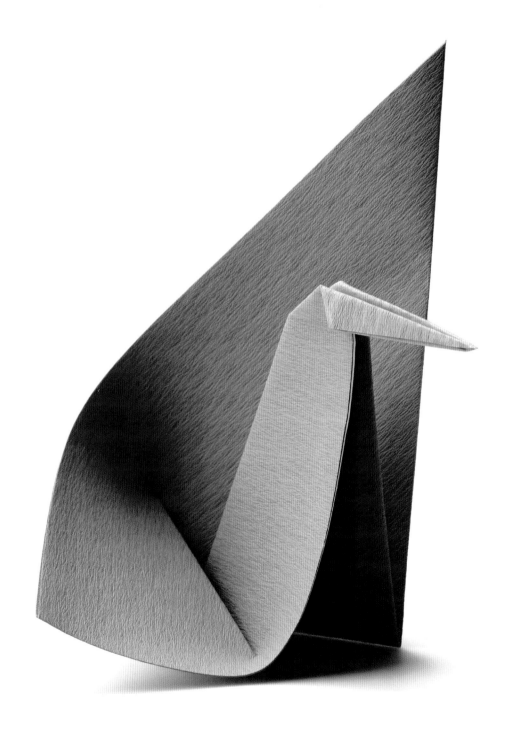

30

Fig. 23
Planta
Paulo Mulatinho
(Brazilian), Brazil
/Germany, 2003,
shin-danshi
Japanese paper
Photo by Herbert
Bungartz

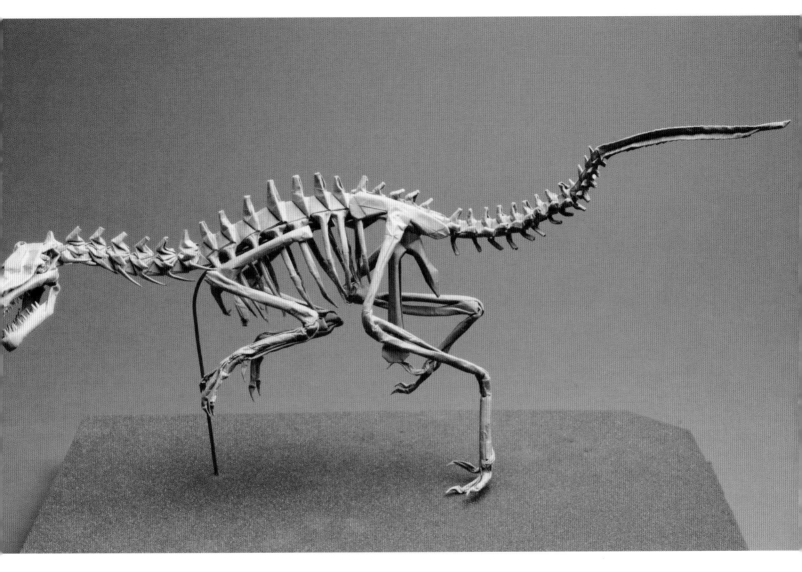

Fig. 24
Velociraptor Skeleton
Hieu Tran Trung
(Vietnamese),
Vietnam, 2011,
over 70 sheets
of uncut square
and rectangular
Vietnamese wrapped
paper

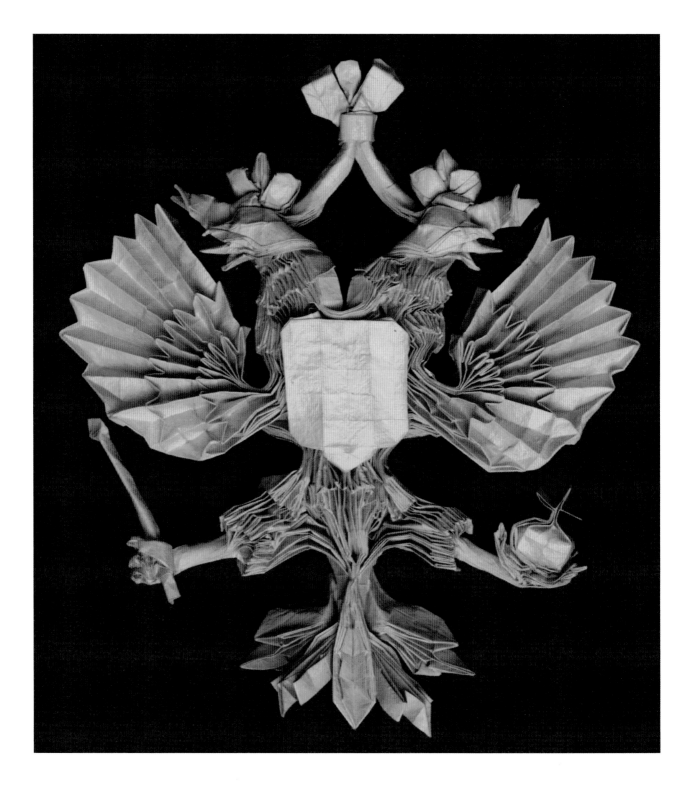

Fig. 25
*Double-headed
Eagle, Russian
State Emblem*
Victoria Serova
(Russian), Russia,
2011, wrapping
paper
Photo by Vladimir
Serova

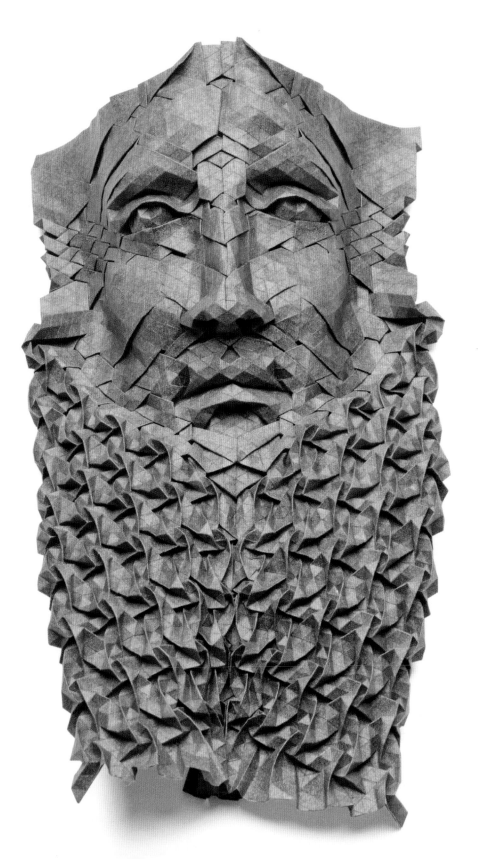

Fig. 26
Cyrus
Joel Cooper
(American), USA,
2010, paper and
shellac

Fig. 27
Frog
Michael G. LaFosse
(American), USA
2003, handmade
paper, abaca fiber
and powdered mica
paper
Photo courtesy of
Mingei International
Museum (San Diego),
gift of V'Ann Cornelius

ancient dinosaur, Tran Trung builds his skeletons out of many square and rectangular sheets of paper all folded individually and attached using glue and wire to create an exquisite sculptural recreation of the frames of these awesome beasts (fig. 24, page 31). American Joel Cooper forms elaborate masks portraying historical and imaginary characters using origami tessellations. In origami, tessellations are often created using pleats to connect elements such as twist folds in a repeating fashion, resulting in a patterned surface reminiscent of Middle Eastern tile work. Tessellations are very complex creations, but are typically two-dimensional and geometric. Cooper has pushed this medium into a third dimension to create sculptural portraits that appear to be woven out of paper yet show great emotional sensitivity (fig. 26, page 33).

The second category of representational origami includes works that possess a strong sense of naturalism. Yoshizawa introduced the wet-folding technique, which allowed him to smooth down sharp points and angles of his models and give them a sculpted look. This technique has enabled many subsequent artists to create forms that appear sculpted or modeled rather than folded. American Michael G. LaFosse, a biologist by training, is one of the main proponents of this type of origami. With his partner, Richard Alexander, LaFosse produces richly textured, colored and patterned papers that enhance artists' ability to create realistic models of ani-

mals, birds and insects. His figure of a frog, for example, not only has the taut, muscular form of a frog poised to leap, created by skillful wet-folding, but the natural dark green tone and the sleek shine of the amphibian's skin, achieved using handmade paper made with abaca fiber and infused with powdered mica (fig. 27, opposite). The result is a naturalistic sculpture that almost appears to be cast in bronze.

Another great artist in this category was French folder Eric Joisel, whose recent death was a tragic loss to the origami world. A sculptor with a background in history and law, Joisel was inspired by the works of Yoshizawa to turn his hands to origami. Largely self-taught in origami techniques, he mastered wet-folding so superbly that many of his figures and animals appear dynamic, engaging, and imbued with life. He excelled at animals, whimsical fantasy figures such as dwarves and wizards, and masks, often depicting the faces of fellow origami enthusiasts. His pangolin (fig. 28, page 36) is a supreme example of his ability to employ origami techniques to form a creature that is so lifelike it almost appears to be breathing. Sculpture of such quality is rare in stone, clay or any other media. With Joisel, it attained the level of masterpiece.

Also from France, Vincent Floderer has taken a very different approach to naturalism. Floderer moved away from conventional origami with its geometric folds, and developed a whole new vocabulary of techniques, most

famously crumpling. The inspiration for his crumpling came originally from British folder Paul Jackson, but Floderer has advanced Jackson's ideas and evolved methods—including dampening and stretching—that have allowed him to create organic forms such as mushrooms and toadstools and multi-layered forms like corals and sponges (see page 38). Turning paper inside out has also resulted in organic abstract creations (fig. 30, page 38). Though a far cry from traditional origami, Floderer's work is embraced in the origami community and has influenced many other artists.

American Dr. Bernie Peyton pushes the limits of traditional origami to make art that is also permanent. Peyton, who is a wildlife biologist, creates pieces that relate to his fieldwork with wildlife and portray endangered creatures in their natural environment. He sometimes paints his paper and applies resin to its surface, and builds armatures out of wire, thread, cloth and wood to lend life and context to his more traditionally folded paper sculptures. His bi-colored creations are folded from one sheet of paper made by gluing two colored sheets of paper together in a process called "backcoating." His piece *Frog on a Leaf*, depicting a red-eyed tree frog perched on a large rain forest leaf, exemplifies his approach. The composition of the piece, with the balanced interplay of the bold geometric form of the giant leaf and the naturalistic detailing of the tiny frog, creates dramatic tension as we sense the vulnerability of the tiny frog (see pages 6 and 7).

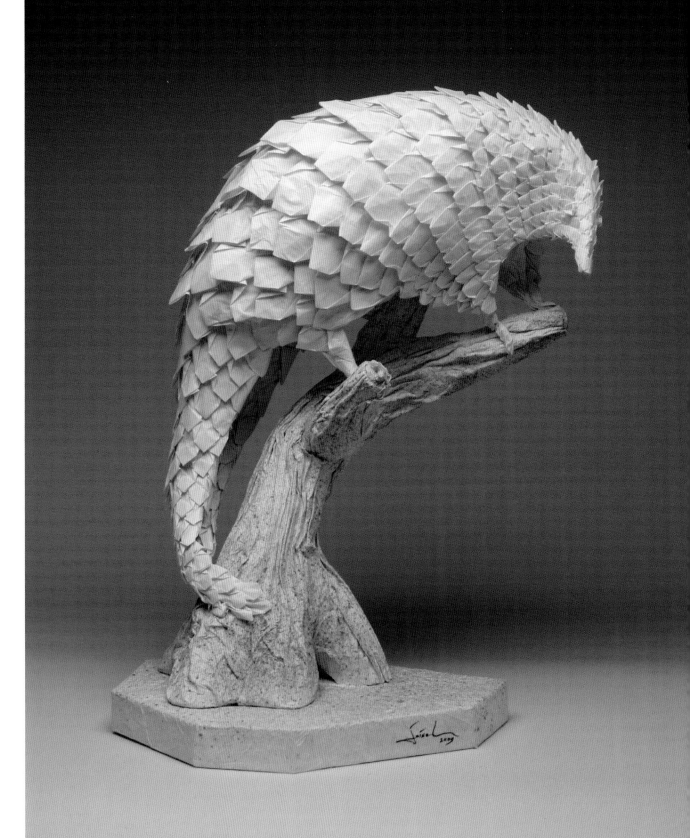

Fig. 28
Pangolin
Eric Joisel (1956–
2010, French),
France, 2009,
pangolin: one uncut
square of paper:
support and base:
paper, wire and paint
Photo courtesy of
Robert J. Lang

(opposite page)
Fig. 29
Detail of *Summer*
Ikebana
John Blackman
(American), USA,
2010, various
papers, wire and
florist tape
Photo by Tom Neely

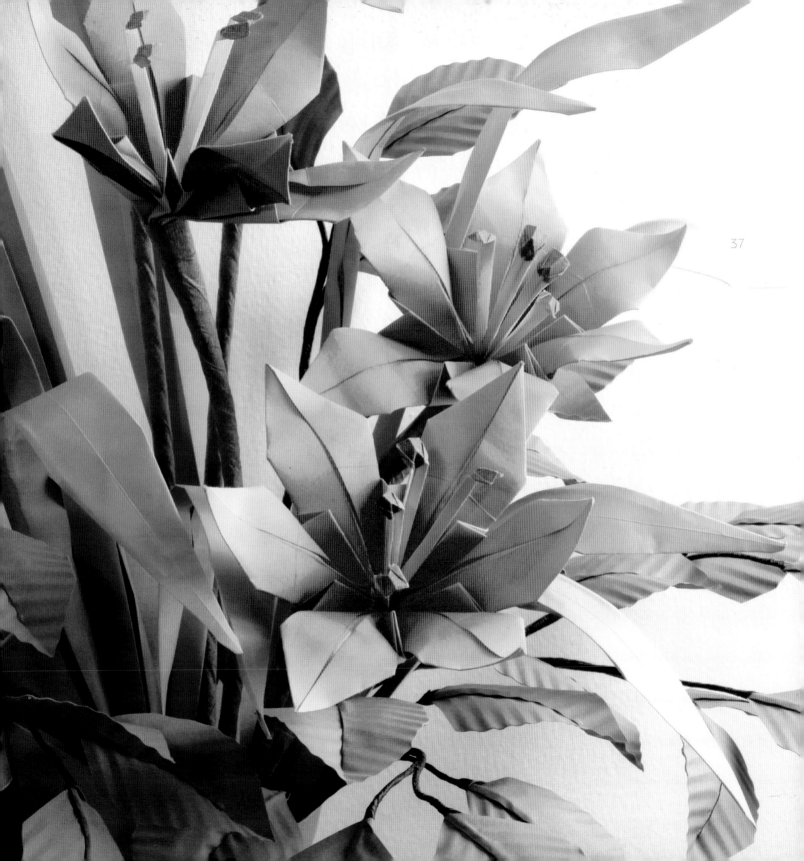

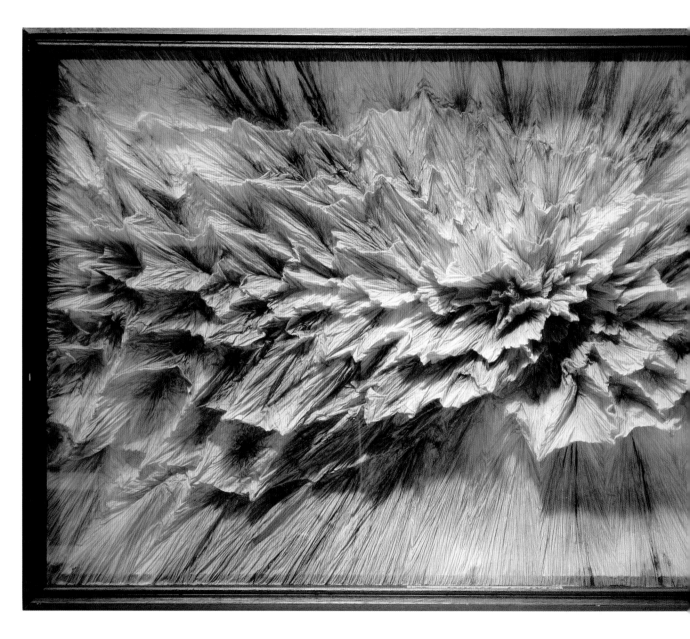

Fig. 30
Boom!
Vincent Floderer
(French), France,
2000, wenzhou
calligraphy paper,
watercolor, Indian ink
on wood frame with
glass
Photo courtesy of
Mingei International
Museum (San Diego),
gift of the artist

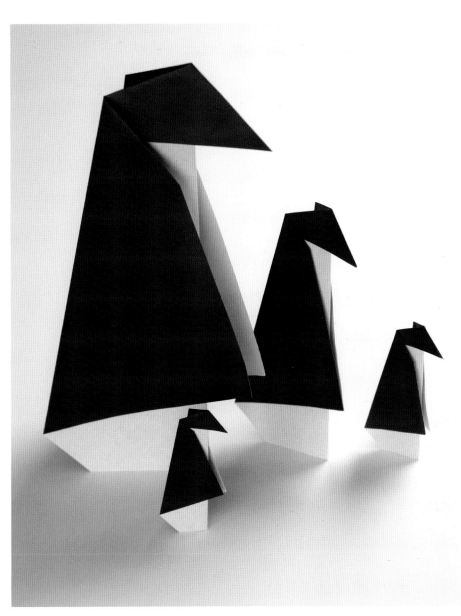

Fig. 31
Group of Penguins
Florence Temko
(British/American,
1921–2009), USA,
2008, paper
Photo courtesy of
Mingei International
Museum (San Diego),
gift of the artist

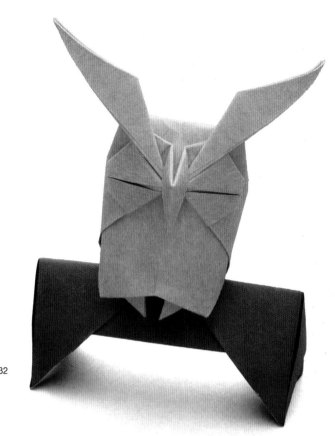

32

Fellow American folder John Blackman has also mastered a very particular portrayal of the natural world. A practitioner of the Japanese art of flower arrangement, or *ikebana*, Blackman folds delicate flowers from different colored and textured paper and arranges them in origami vases to create seasonal floral displays, such as the sumptuous summer arrangement of lilies featured in the exhibition (fig. 29, page 37). Like Peyton, he also uses wires and tape, and with the aid of these tools, he achieves a lyrical and well-balanced composition—the goal of real flower arrangement.

A final group of representational pieces are expressionistic representations of nature. These works do not involve the extremely complex folding of the first group; nor are they as naturalistic as the second group. Instead, they are generally stylized, sometimes partially abstracted. Some are serious and spiritual, while others are playful and whimsical. Florence Temko, one of the pioneers of origami in the U.S., was also a teacher and author of instructional origami books. Much of her work would probably be categorized as craft. However, some of her designs are so elegant and full of expression that they have transcended craft and entered into the realm of art. Her group of penguins, made from a few careful folds of dual-colored paper, is both elegant and expressive (fig. 31, page 39). Brazilian Paulo Mulatinho's crane *Planta* is a minimalist masterpiece, which evokes the graceful spirit of this beloved bird with only three folds (fig. 23, page 30).

The animal masks of the late Japanese American artist Roy Iwaki also powerfully express the spirit and character of the creatures he portrays. Made of plain white paper formed largely using curved folds, the stylized faces of his tigers and bulls are animated by the interplay of light and shadow among the dramatic folds (fig. 33, opposite). Stylization of the natural world is probably at its most spiritual in the works of Vietnamese American artist Giang Dinh. Trained as an architect, Dinh is well known for his simple, elegant designs. Like Iwaki, he often works in plain white or pale brown paper so that the viewer can concentrate on the pure form and shadow of the work. However, rather than crisp, sharp folds, which he compares to ink,

he chooses soft folds, which he likens to pencil lines. Many of his works are wet-folded out of watercolor paper and have the appearance of semi-abstract sculptures, such as his tall, mysterious figure in *Prayer* (fig. 35, opposite), and the magical depiction of sheets of paper transforming into egrets in *Fly* (fig. 7, page 15), his work based on Hokusai's depiction of Abe no Seimei.

In contrast to this spiritual approach, other artists have favored a playful stylization of natural forms in their works. This quality is apparent in many of the designs of Japanese artist Hideo Komatsu. His *Horned Owl* (fig. 32) shares the geometric approach of traditional origami animals, but here, the angular

Fig. 32
Horned Owl
Hideo Komatsu
(Japanese), Japan,
1997, one uncut
square of Japanese
paper

(opposite page)
Fig. 33
Tiger Mask
Roy Iwaki (Japanese
American, 1935–
2010), USA, 1986,
paper

(opposite page)
Fig. 34
Lion
Nicolas Terry
(French), France,
2004, natural tissue
paper, glue on foil

(opposite page)
Fig. 35
Prayer
Giang Dinh (Vietnamese
American), Vietnam/
USA, 2010,
watercolor paper

33

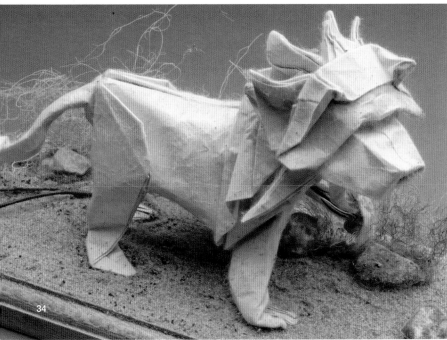

34

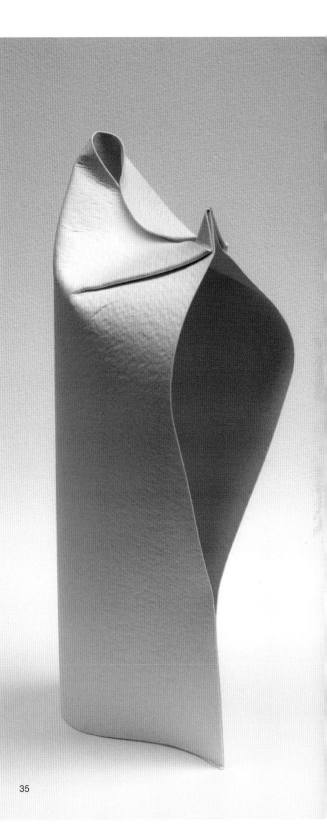

35

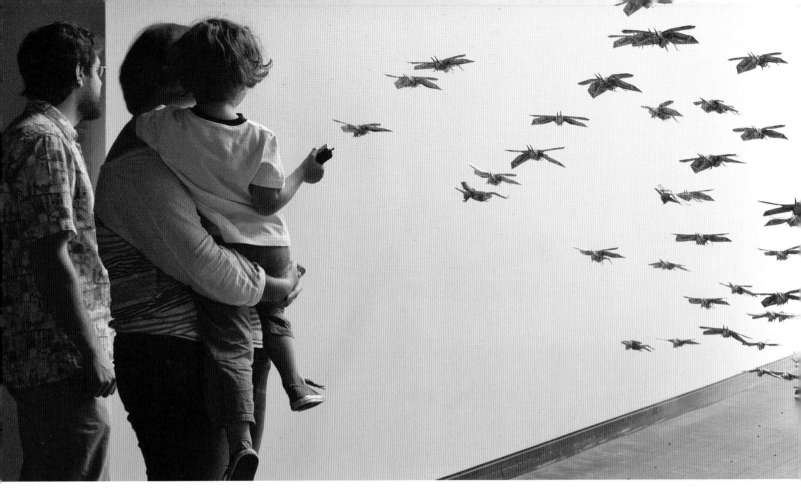

treatment of the details of the owl's facial features, with its tightly closed eyes and accentuated horns, adds a gentle touch of humor to this otherwise noble creature. Makoto Yamaguchi, one of Japan's most active origami artists, is also a master of elegant stylization. In his work *Renjishi*, he creates two figures representing the actors from a *kabuki* play about a pair of *shishi* lions. In the play, the father lion has white hair and his cub has red hair but here, Yamaguchi's figures are so abbreviated they have no bodies or heads—only the actors' robes, the white robe alluding to the father, the red to the cub. A

similar approach is found in the works of French artist Nicolas Terry, whose animal forms are often full of humor and whimsy. His lion, wet-folded out of a mustard-colored natural tissue paper, appears far from fierce with his thick paws, heavy brow and gentle expression (fig. 34, page 41). Whimsy is also apparent in the works of American Jared Needle, who folds many creatures from the world of fantasy. His own creation, *Bunny God*, is a quirky blend of rabbit and dragon reminiscent of the bizarre creatures that inhabit Japanese anime films and video games. Indeed, many younger folders such as Needle

draw their inspiration from this world (fig. 37, page 44).

Within the category of representational origami art are works that represent more than their actual physical form. Belgian folder and computer programmer Herman van Goubergen folds figures from the natural world, such as ducks, fish, and lizards in a manner that deliberately tricks the viewer. For example, viewed from one angle, his works appear to be swans but from another, they are fish. His trompe l'oeil works are not always what they first appear, as in the case of his origami

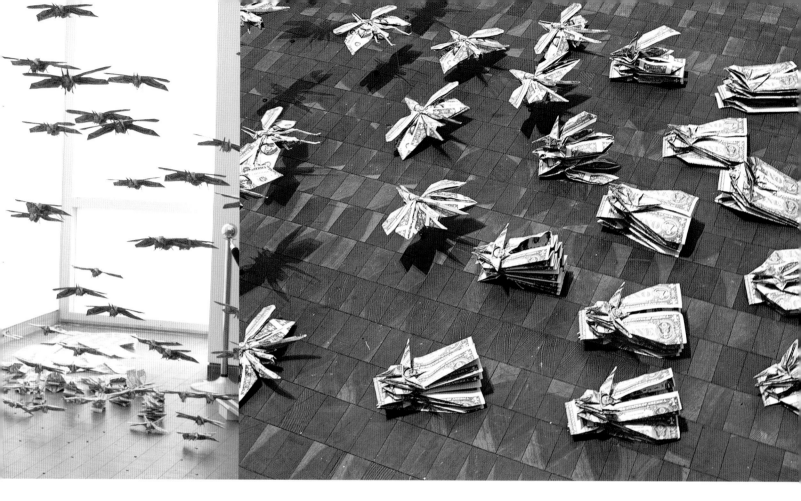

Skull, which is not actually a complete skull (fig. 38, page 45). What he has folded out of paper is the top part of a skull, and only when it is laid atop a mirror does a full skull, completed by its reflection, appear.

Artists such as Miri Golan and Sipho Mabona use folded figures of animals and people to make social and political comments. We have already seen Golan's work *Two Books*, in which folded human figures spill out of two holy books to represent the potential unity of Israelis and Palestinians (fig. 21, pages 26 and 27). Mabona is an artist of Swiss and South African background, whose impeccable folding of elaborate insects and other creatures rank him among the top complex origami artists. However, Mabona has recently distinguished himself as one of the first origami artists specializing in installations, arranging his folded paper figures of people, animals, birds, fish, and insects in galleries and interior public spaces to convey potent social messages. His 2010 work *Bearly Surviving*, which depicts dozens of polar bears crowded together on a shrinking iceberg, is a poignant visual commentary on the damage caused by climate change. His installation *Much Ado About Nothing*, also from 2010, in which folded paper human figures dangle from balloons or just from the ceiling, invites reflection on both the lightness and gloom of the human condition. Mabona designed an installation specifically for *Folding Paper* entitled *The Plague*, in which he transforms U.S. dollar bills into a storm of locusts. As the locusts take shape from sheets of money, they swarm around the gallery, a haunting reminder of the dark side of our consumer culture (fig. 36).

Fig. 36
The Plague
Sipho Mabona
(Swiss/South African), USA, 2012, U.S. dollar bills
Photos by Simon Fong

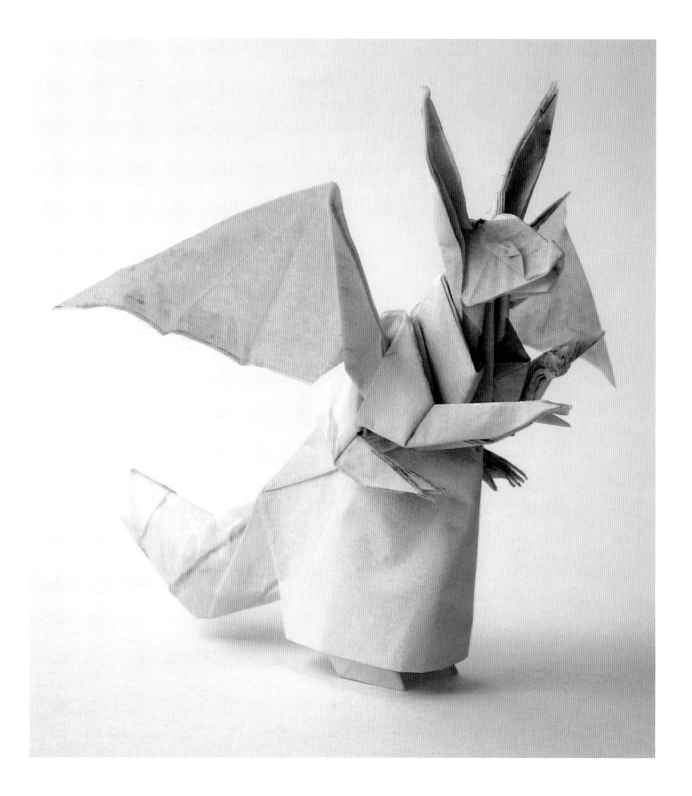

44

Fig. 37
Bunny God
Jared Needle
(American), USA,
2011, one 16-inch
square of *sekishu
tsuru* paper
Photo courtesy of
the artist

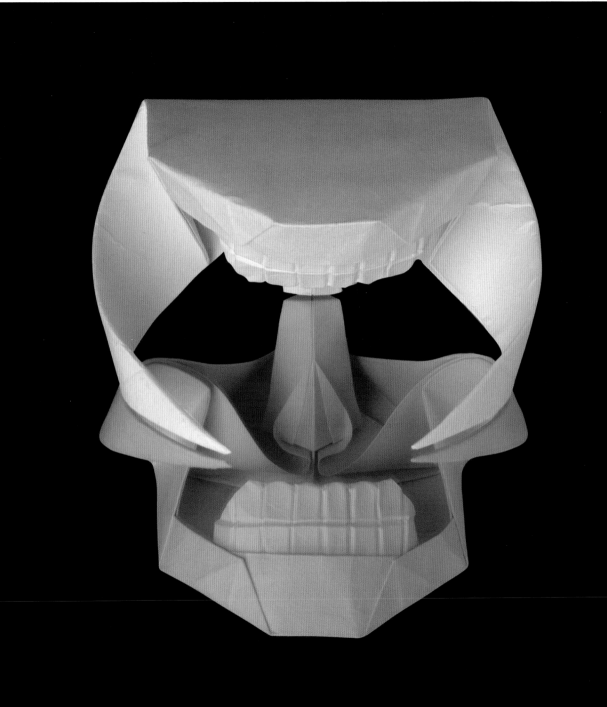

Fig. 38
Skull
Herman Van
Goubergen (Belgian),
Belgium, 2010,
elephant hide
(*Elefantenhaut*) paper
and mirror
Photo by Lynton
Gardiner, courtesy of
Mingei International
Museum (San Diego),
gift of the artist

ANGLES AND ABSTRACTIONS:
Geometric Forms and Abstract Constructions

While much of the artistic origami created worldwide is representational, an increasing number of artists are folding works that are either geometric forms or abstract constructions. As with the representational works, the more mathematically complex geometric origami is generally made by artists with a strong mathematical background, while the more abstract non-figural works tend to be the realm of artists with sculptural or philosophical leanings. However, as in the case of the representational pieces, it is not always easy to categorize certain artists who have mastered many of the different types.

There are two main types of geometric origami—modular origami and origami tessellations. Both are mathematically challenging to make and aesthetically exciting to behold. In modular origami, multiple sheets of paper are folded into individual units and then assembled into a larger, more complex structure, which is held together by friction or tension, such as that created by inserting flaps from one module into pockets of another. Most modular forms are polyhedra, or geometric solids in three dimensions with flat faces and straight edges, and these vary in complexity. American artist and mathematician Tom Hull is a master of this type of origami, and some of his modular works are extraordinarily complex. His *Spiked Rhombic Enneacontahedron* made in 2005 using 180 squares of paper is a polyhedron composed of 90 rhombic faces, with three, five, or six rhombi meeting at each vertex (fig. 44, opposite). Hull's selection of cool and warm tones for the different modules works harmoniously with the dramatic jagged yet symmetrical form to create a well-balanced geometric sculpture. A similar compatibility of color and form characterizes the work of Chinese American Daniel Kwan. In his work titled *Six Interlocking Pentagonal Prisms* (2010), he folded 90 rectangular sheets into six slender pentagonal sections that he then assembled to create a structure that evokes loosely woven basketry (fig. 39, opposite).

The orbs of American Jeannine Mosely are examples of modular origami at its most elegant. A graduate of MIT with a Ph.D. in electrical engineering and computer science, Mosely has pursued a career in three-dimensional modeling, believing that folding origami structures is a way of giving life to a mathematical theorem or formula. Her mastery of curved folding has enabled her to create such poetic forms as her 2010 *Triacontahedral Orb*, in which each of the orb's 30 faces is a recessed circle, like the craters of a perfectly symmetrical moon (fig. 40, opposite). Another modular poet, Japanese artist Miyuki Kawamura, also specializes in modular origami, but chooses to give her pieces lyrical names, removing them slightly from the world of geometry. Her piece *Turbulence*, constructed in 2000 using 30 squares of paper, has calm symmetry in its overall form, but its spiraling surface pattern suggests the swirling energy of whirlwinds or tornadoes (fig. 41, opposite).

Typically, modulars are geometric structures created using mathematical calculations. However, other multi-unit origami forms including the traditional Japanese *kusudama*, balls made by sewing or gluing together separate, usually flower-shaped, units, can also be considered modular, although they are held together with adhesive or thread. Such forms were originally championed and popularized by Japanese artist Tomoko Fuse and have inspired the work of artists such as Krystyna and Wojtek Burczyk, a Polish couple who specialize in twisted floral forms, based on the curler unit concept originally developed by Herman van Goubergen. Their spectacular forms are built up out of multiple sheets of richly colored and textured papers, and although the Burczyks have a background in mathematics, the curves and swirls of their pieces appear to owe less to geometry and mathematics and more to the natural world (fig. 42, opposite).

Another category of modular origami that has been gaining momentum among folders worldwide is strip-folding origami, developed by German artist Heinz Strobl. In this form of origami, long strips of paper replace squares and rectangles. Strobl created and named two variations of strip-folding. In *Snapology*, one set of paper strips are folded into triangular prisms (the units or modules). Another set of strips are folded into snaps (connectors).

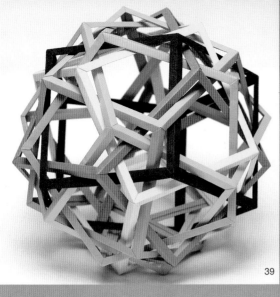

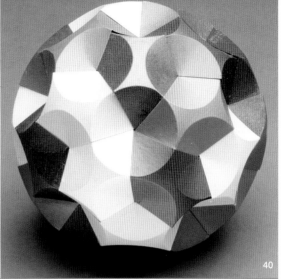

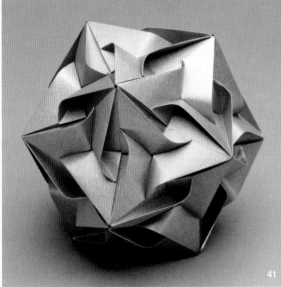

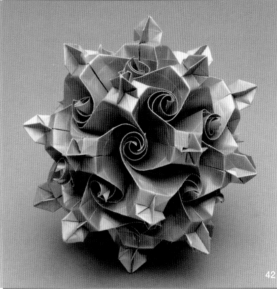

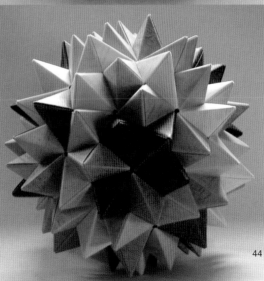

Fig. 39
Six Interlocking Pentagonal Prisms
Daniel Kwan (Chinese American), USA, 2010, 90 rectangles of paper
Photo by Shue-Yu Kwan

Fig. 40
Triacontahedral Orb
Jeannine Mosely (American), USA, 2010, colored art paper

Fig. 41
Turbulence
Miyuki Kawamura (Japanese), Japan, 2000, 30 pieces of square paper

Fig. 42
Mosaic Twirl
Krystyna and Wojtek Burczyk (Polish), Poland, 2007, 24 pieces of metallic paper

Fig. 43
Sphere 94
Heinz Strobl (German), Germany, 2010, Hydrofix paper tape
Photo courtesy of the artist

Fig. 44
Spiked Rhombic Enneacontahedron
Tom Hull (American), USA, 2005, one hundred eighty 4-inch squares of Japanese artisan paper
Photo by Nancy Marshall

(opposite page)
Fig. 45
Whirlpool Pattern 00810
Tomoko Fuse
(Japanese), Japan,
2003, *washi* paper
Photo by Lynton
Gardiner, courtesy of
Mingei International
Museum (San Diego),
gift of the artist

Geometric forms, such as spheres, are assembled by using the snaps to connect the units. In *Knotology*, the strips are knotted into flat pentagons layered on one another, and woven and plaited to make models that, like his *Snapology* figures, are stable without the use of glue or tape, as in *Sphere 94*, a strip-folded paper sculpture created by Strobl in 2010 (fig. 43, page 47).

Although they appear modular in their final form, Japanese American Linda Tomoko Mihara's crane cubes and spheres are not technically modular, since they are constructed from a single sheet of paper that is cut into sections that remain connected throughout the folding process. The practice of folding multiple cranes from a single sheet of paper is known as *renzuru*, or *roko-an*, and is illustrated in the eighteenth century book *Hiden Senbazuru Orikata* (*Secret Folding Methods for One Thousand Cranes*). Mihara developed the *Crane Cube* and *Peace Sphere* after practicing this technique for many years. It took five years to find the right type of paper to make her *Peace Sphere* a free-standing, round sculpture (fig. 19, page 24). Also, although not modular origami, some of the decorative box lids created by American physicist Arnold Tubis, are folded from two-colored paper so that both colors are featured together on the same surface, creating the appearance of connected elements (page 97).

The other main type of geometric origami is the origami tessellation. In a tessellation, a pattern fills a plane with no overlaps or gaps, like decorative wall tiles. Origami tessellations are often created using pleats to connect together elements such as twist folds in a repeating fashion. Many origami tessellations have the appearance of woven paper and can be extremely dramatic when well lit, particularly from the back. Japanese origami artist Tomoko Fuse, well known for her contributions to the world of modular origami, also creates exquisitely colored and textured tessellations such as *Whirlpool Pattern 00810* (2003), which has the appearance of a woven textile (fig. 45, opposite). Exceptionally intricate detailing can be seen in the works of American Christine Edison, whose *Snowstorm* (2007) is a masterful example of the dramatic patterning that can be created using a single sheet of white paper (fig. 48, page 50). Robert J. Lang, best known for his complex origami creatures, also crosses over into the realm of modulars and tessellations. His piece *3^7 Hyperbolic Limit, opus 600* (2011), a tessellation of triangles and heptagons frolicking together between light and shadow, makes its debut appearance in the *Folding Paper* exhibition (fig. 47, page 50).

Many American tessellation artists are pushing the boundaries of this form, forcing it into three dimensions. Eric Gjerde is among the most active of these artists, publishing books and blogs on the subject and sharing designs and ideas with other artists and enthusiasts. His *Vertebral Stretch* (2007), with its three parallel, zig-zagging spines rising up in relief from a flat patterned ground, is typical of the three-dimensional tessellations he is currently producing (fig. 46, page 50). Croatian American Goran Konjevod works with a variety of different types of paper in his exploration of three-dimensional tessellations. For flatter works, fine Japanese *tengu-joshi* paper is ideal for accentuating the shadowy folds of the patterns, but for dramatic three-dimensional work such as *Double Wave* (2007), thicker elephant hide paper adds volume and holds the curves of this elegantly balanced form (fig. 50, page 52). Christine Edison also works in three dimensions, and Joel Cooper is, as we have already seen, creating elaborate masks in this medium. Linda Tomoko Mihara, better known for her crane sculptures, has also created a tessellation dress and matching shoes, featured in this exhibition, each from a single sheet of uncut paper (fig. 57, page 58). British artist Polly Verity, who sculpts in a wide range of media, is exploring origami tessellations as a medium for abstract expressionist sculpture. Her work, *Multiple Mushroom Crumple*, is three-dimensional crumpled tessellation with a strong organic sensibility (fig. 49, page 51).

Closely related to tessellations are the geometric paper sculptures of artists such as David Huffman and Erik and Martin Demaine. They often feature geometric surface patterning and repeated folded elements, but are generally more expansive in overall form and composition. Huffman was an electrical engineer and a pioneer in

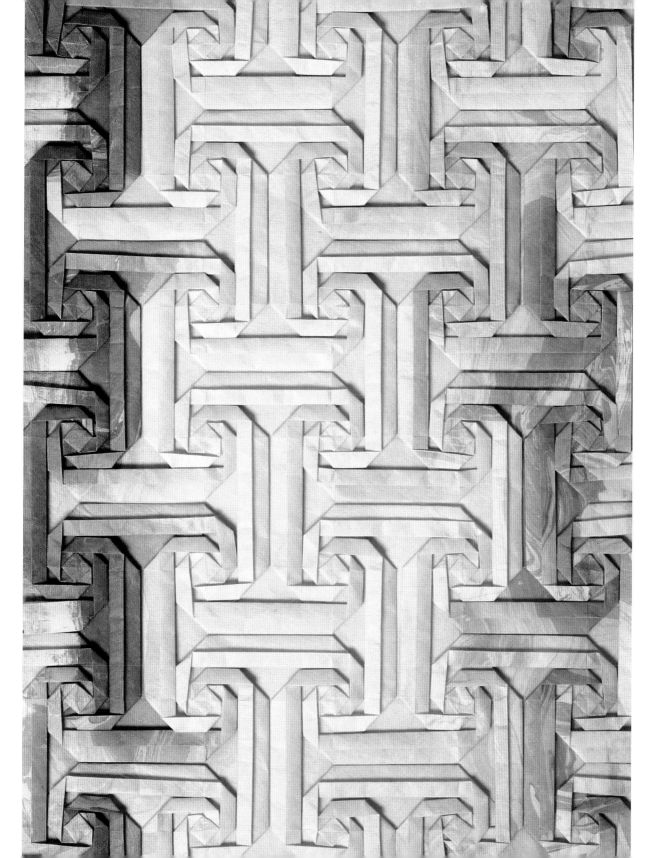

50

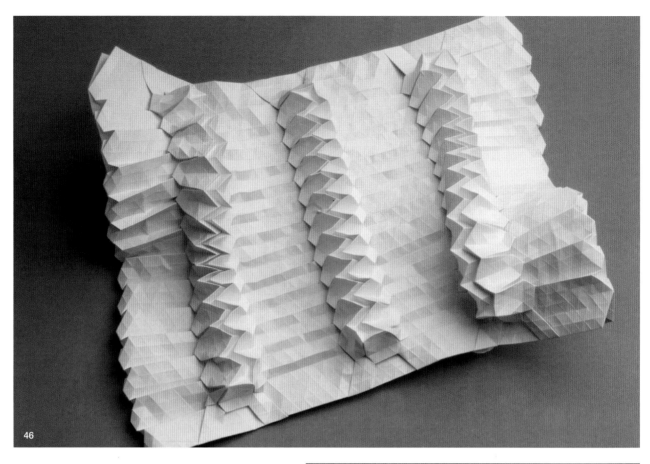

46

Fig. 46
Vertebral Stretch
Eric Gjerde
(Norwegian
American), France,
2007, elephant
hide (*Elefantenhaut*)
paper

Fig. 47
*3⁷ Hyperbolic
Limit, opus 600*
Robert J. Lang
(American), USA,
2011, one uncut
sheet of glassine
paper
Photo courtesy of
the artist

Fig. 48
Snowstorm
Christine Edison
(American), USA,
2007, Wyndstone
Marble Paper
Photo courtesy of
the artist

47

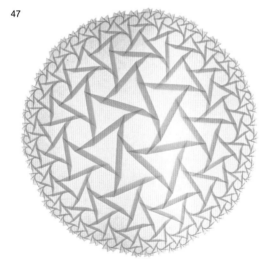

48

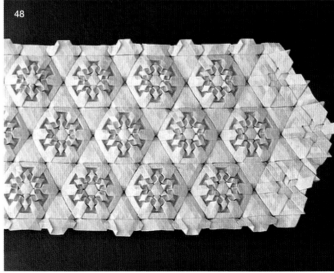

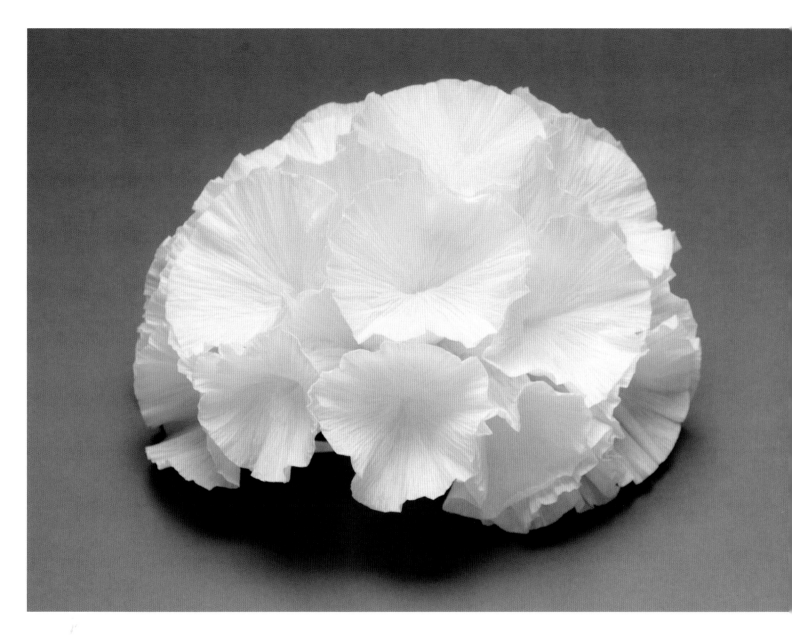

Fig. 49
Multiple
Mushroom
Crumple
Polly Verity (British),
UK, 2010, acid-free
tissue paper

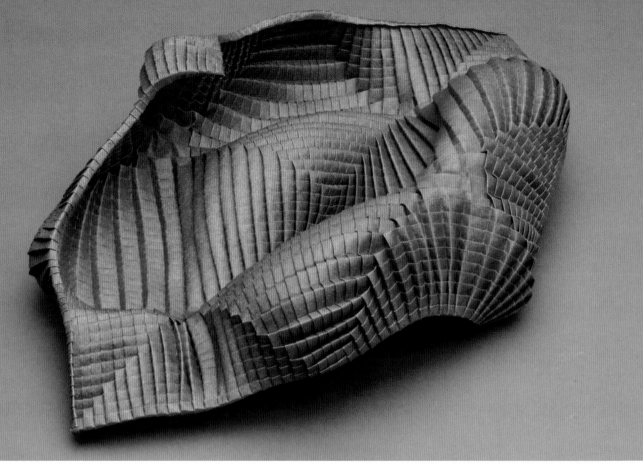

Fig. 50
Double Wave
Goran Konjevod
(Croatian
American),
USA, 2007, one
24-inch square
of elephant hide
(*Elefantenhaut*)
paper

Fig. 51
***Great Wave Off
Kanagawa***
Andrea Russo
(Italian), Italy, 2010,
paper
Photo by Fabio
Giulianelli

Fig. 52
***03M (Partial
Shell)***
Richard Sweeney
(British), UK,
2010, wet-folded
watercolor paper
Photo courtesy of
the artist

50

51

52

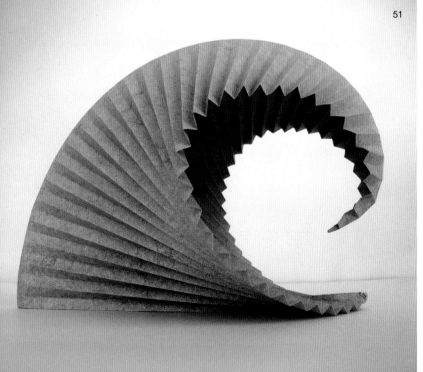

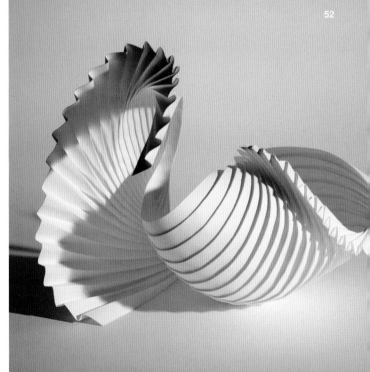

computational origami. He also developed structures based around curved folds, greatly impacting current paper folding and inspiring such artists as Jeannine Mosely. His *Hexagonal Tower*, which he originally folded out of paper in the 1970s, was recreated out of PVC for this exhibition by Erik and Martin Demaine and Duks Koschitz (fig. 54, page 55). The Demaines are a Canadian/American father-son artistic team, whose Curved-Crease Sculptures were inspired by Huffman's curved folding. Erik Demaine is the world's leading theoretician in computational origami, the study of what can be done with a folded sheet of paper, and he is exploring origami applications to architecture, robotics, and molecular biology. He and his father Martin Demaine, fold, pleat, and twist paper into powerful sculptural forms that are held together by the tension of the folding and twisting. An example of their powerful paper sculptures is *Splash II*, a work that is at once geometric and sensual (fig. 55, page 56).

Sensuality also permeates the folded paper sculptures of British artist Richard Sweeney, who specialized in sculpture and three-dimensional design. As a sculptor, Sweeney seeks to maintain an experimental, hands-on approach, utilizing the unique properties of often mundane materials, such as paper, to discover unique sculptural forms. His 2010 work *03M (Partial Shell)*, is wetfolded out of watercolor paper into a gracefully swirling organic form (fig. 52, opposite page and cover). Sweeney

creates such abstract forms on a larger scale for installation pieces that he suspends from the ceiling of galleries and public spaces. Italian Andrea Russo adopts a similar approach, pleating and twisting paper into curves, circles, and waves. His *Great Wave off Kanagawa* (2010) is a powerful three-dimensional interpretation of Hokusai's famous woodblock print depicting a huge wave in front of Mount Fuji. In Russo's *Great Wave*, the tension holding the paper in its form evokes the moment in Hokusai's print when the gigantic, curling wave threatens to swallow three fishing boats (fig. 51, opposite).

The final two artists in the exhibition excel in pushing folded paper sculptures towards abstraction. Paul Jackson, a British artist with a background in design, takes a philosophical approach to paper folding, preferring forms that appear to have been "discovered" in the paper, rather than "contrived" from it. His exploration of crumpling as an artistic folding method inspired Vincent Floderer and other artists, and pieces such as *Organic Abstract*, 2011, which he colors by hand using pastels, are folded and then released, allowing the paper to choose its own form, like a flower spreading its petals (fig. 75, pages 76 and 77). According to Jackson, many of his works aspire to be "simple, elegant in sequence and form, surprising in concept and even audacious," qualities that are apparent in his single fold sculptures and works such as *Duet*, in which he uses a gentle crease (not even a complete fold) that

makes two rectangles appear to dance (fig. 53, page 54). In Japan, Koshiro Hatori echoes Jackson's approach in works such as *Double Pleats No. 4*, 2005, the ultimate in abstract minimalism in origami. Barely folded from a torn sheet of Japanese *kozo* paper, the work evokes the simplicity and mystery of a splashed-ink Zen landscape painting (fig. 56, page 57).

Origami has been transformed in the last 50 years. Paper folders from all over the world have been able to explore a rich assortment of paper types, folding techniques and styles, and so doing have revolutionized paper folding into one of the world's most exciting and dynamic new art forms. Now, at the start of a new millennium, origami art works are impressive not only for their technical skill but for their rich aesthetic and emotional expression, and many of them can stand proudly beside painting, sculpture, and photography in our museums, private galleries and public spaces. With visionary artists unfolding new possibilities in the world of origami, it is exciting to contemplate what will emerge in the coming decades.

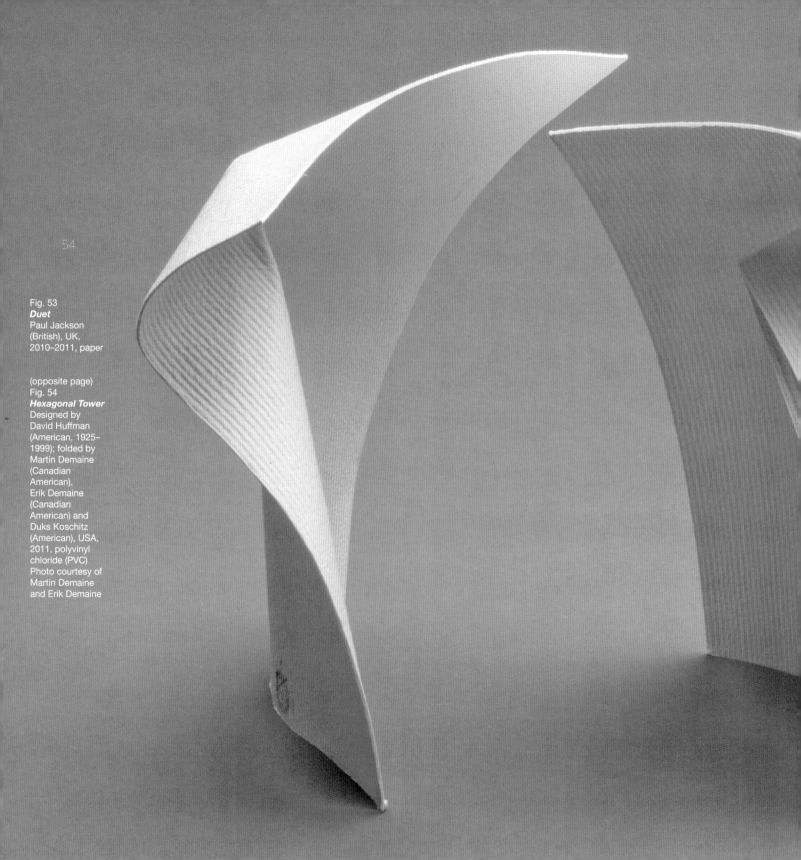

Fig. 53
Duet
Paul Jackson
(British), UK,
2010–2011, paper

(opposite page)
Fig. 54
Hexagonal Tower
Designed by
David Huffman
(American, 1925–
1999); folded by
Martin Demaine
(Canadian
American),
Erik Demaine
(Canadian
American) and
Duks Koschitz
(American), USA,
2011, polyvinyl
chloride (PVC)
Photo courtesy of
Martin Demaine
and Erik Demaine

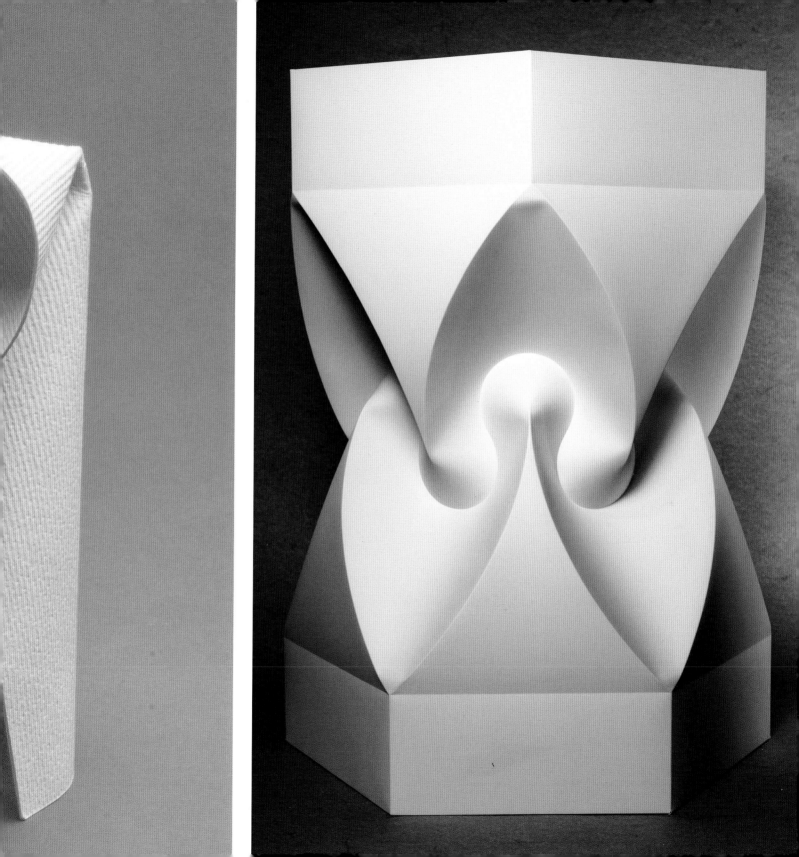

56

Fig. 55
Splash II
Erik and Martin
Demaine (Canadian
American), USA,
2011, Zander's
elephant hide
(*Elefantenhaut*)
paper
Photo courtesy of
the artists

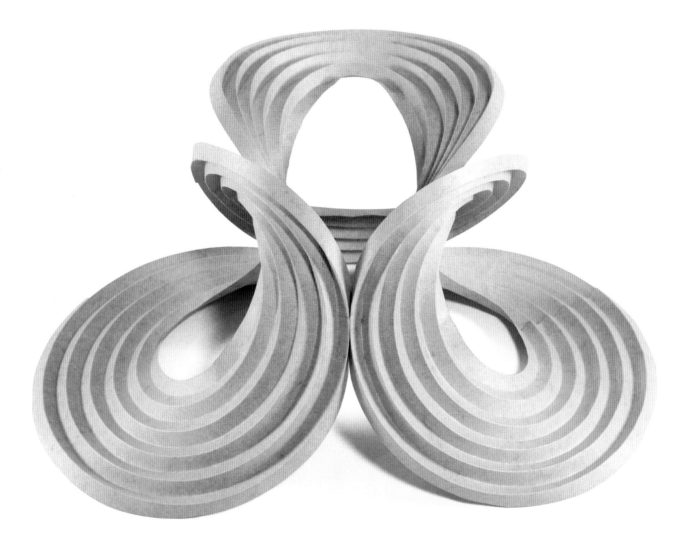

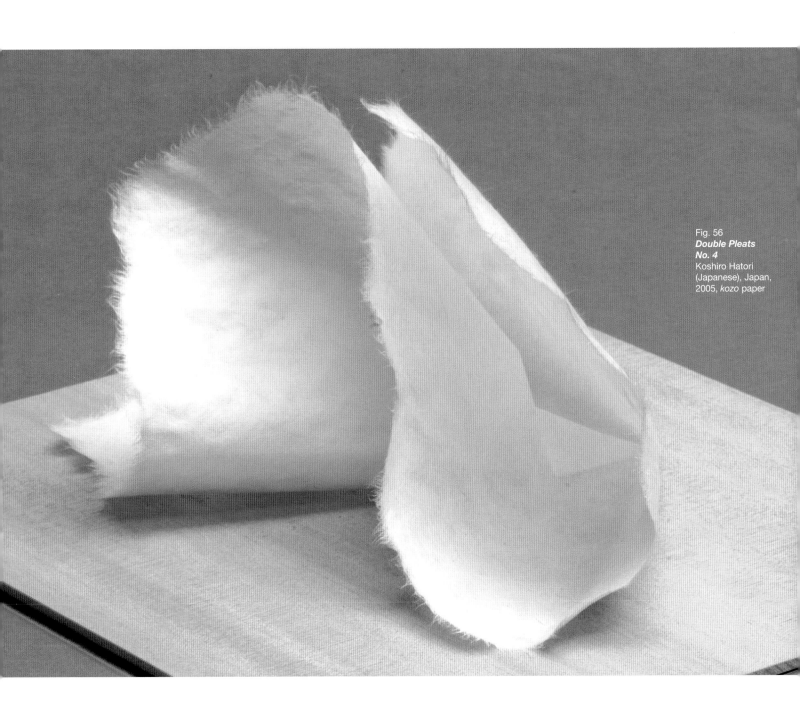

Fig. 56
Double Pleats
No. 4
Koshiro Hatori
(Japanese), Japan,
2005, *kozo* paper

58

Fig. 57
Star Tessellated Dress and High Heels
Linda Tomoko Mihara (Japanese American), USA, 2010, dress and each shoe: folded from a single sheet of parchment, no cuts

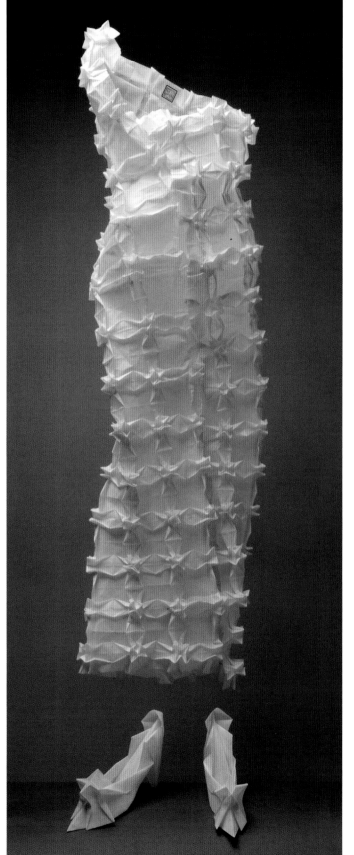

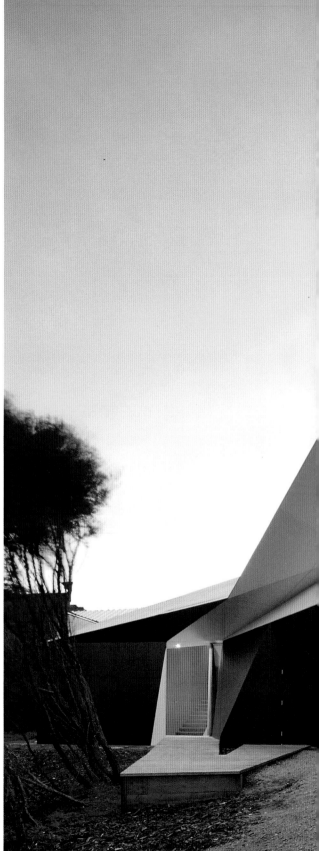

Fig. 58
The Klein Bottle House
Designed by
architectural firm
McBride Charles
Ryan, Australia,
2008
Photo by John
Gollings, courtesy
of McBride Charles
Ryan

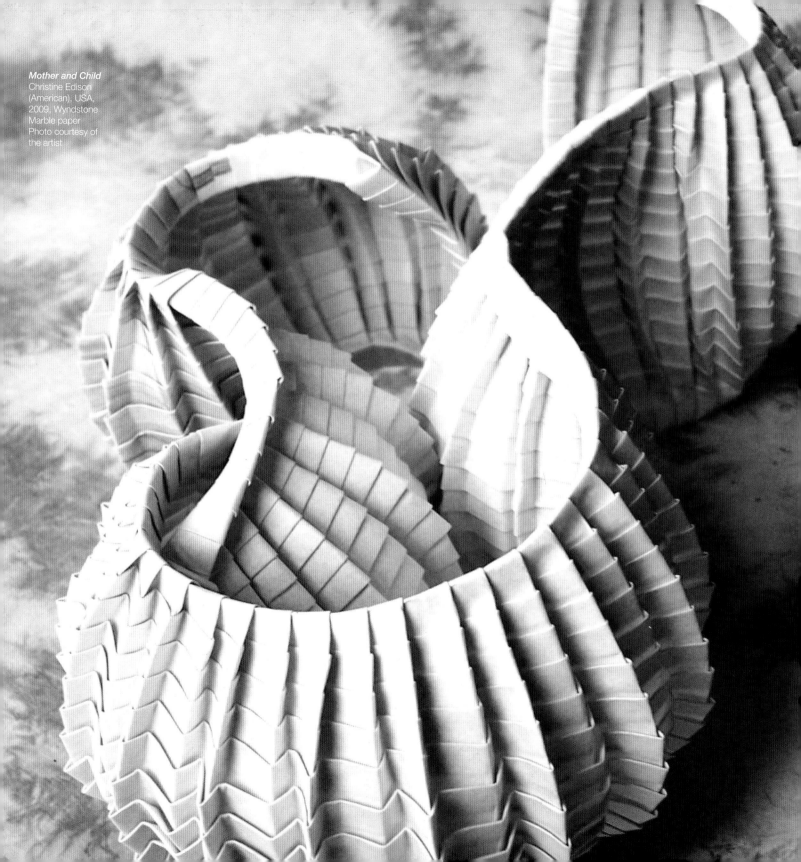

FROM FLAPPING BIRDS TO PACKING CIRCLES: AN ORIGAMI JOURNEY

by **DR. ROBERT J. LANG** Artist & Physicist

> "In the beginning we didn't know what would be possible, but then we tried to push the limits and eventually found that everything could be made."

ERIK DEMAINE Excerpt from *Between the Folds*

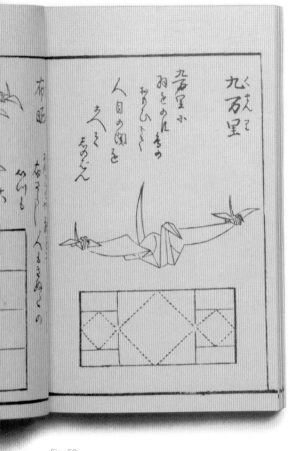

Fig. 59
Reproduction of *Secret Folding Methods for One Thousand Cranes* (*Hiden Senbazuru Orikata*)
Japan, 1797 (reproduction published in 1997), woodblock printed book

OLD AND NEW

In 1959, British scientist and novelist C. P. Snow delivered a lecture, "The Two Cultures," followed by a book of the same name. In both, he bemoaned the chasm between the respective cultures of the humanities and the sciences—a gulf that, by all appearances, persists to this day, if it has not, indeed, widened. However, when the world of art and the world of science meet, the results can be spectacular. And such a meeting took place in the latter half of the twentieth century between two most unlikely fields: on one side, origami, the ancient Japanese art of decorative paper folding, and on the other, mathematics, science, and technology. Both sides emerged richer for the interaction.

At first appearance, the two fields of endeavor would seem to have nothing at all in common. Origami is ancient, creative, intuitive, and aesthetic (see fig. 60). Although we use the modern Japanese word "origami" to describe the art of decorative paper folding, this art is so old that we don't really know its origins, or even who invented it. Paper, in its modern form, can be traced to second century China, and paper-like papyrus is thousands of years older, originating from Egypt. But paper folding? Speculations abound, though the historical record in the East is silent until the 1600s in Japan, when references to folded butterflies can be found in the written word, or the 1700s, when images start to appear in the historical record. Those images are of simple folded figures—birds, boats, human figures—which suggests that even then, figurative origami was regarded as a simple craft or child's pastime.

Those simple figures are folded even today in elementary classrooms in Japan, as well as informally taught in classrooms around the world. Origami might never have progressed beyond this simplicity without the work of Akira Yoshizawa (1911–2005), the man widely regarded as the father of modern origami. Yoshizawa took up his country's traditional craft and devoted his life to it, creating thousands of new figures, including forms imbued with great beauty and life. His work was brought to the West in the 1950s, where it inspired many to take up or extend the art, launching a worldwide renaissance of origami that continues to this day.

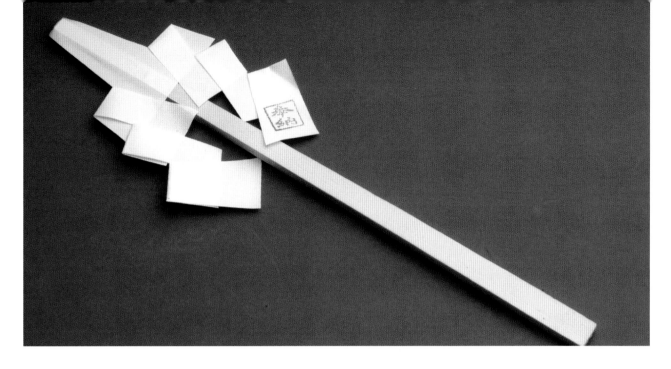

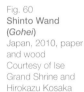

Fig. 60
Shinto Wand
(*Gohei*)
Japan, 2010, paper
and wood
Courtesy of Ise
Grand Shrine and
Hirokazu Kosaka

Yoshizawa's approach to origami was deeply spiritual; he never sold a figure, and commonly began his folding with a prayer. His descriptions of folding sometimes border on the mystical; he once described the process of designing an origami insect, for example, as taking the paper through larval, nymph, and adult stages. As a child, he had learned his country's folk art; as a young man he used it to teach fellow employees at the factory where he worked; but by his mid-20s, it had become a passion, then an obsession, and his full-time livelihood—such as it was. For origami was never particularly respected in the same manner as other Japanese arts like brush painting, ceramics, or lacquer. Origami was regarded as nothing more than a child's pastime, and Yoshizawa struggled financially his whole life so that he could pursue his art.

And pursue it he did. Over the following decades, Yoshizawa created thousands of new origami figures—more than 50,000, by his own count. Though it must be understood that Yoshizawa considered each folded rendering to be a unique figure; if he folded 10 monkeys from the same basic plan, each one counted in his mind as a unique work. And indeed they were: in any grouping of similar figures by Yoshizawa, no two are identical; their poses and expressions all differ in some way, even if the underlying folding sequences are essentially the same.

Yoshizawa was not the only Japanese folder who created new origami figures in the mid-twentieth century; several other folders in Japan launched explorations of their country's folk craft. (This led, at times, to considerable rivalry among the various Japanese masters— somewhat ironically, since outside the world of origami, no one much cared.) Yoshizawa's work came to the attention of the West through the efforts of Gershon Legman in the 1950s; it then tapped into existing Western interests in paper folding (which had long been a mainstay of both childhood crafts and magicians' acts), and inspired further developments in the art, both in the West (notably through the efforts of Lillian Oppenheimer in the U.S. and Robert Harbin in the U.K.), and in Japan.

LANGUAGE

Snow lamented in his essay that scientists and those in the humanities seemed to speak different metaphoric languages: each had their own specialized concepts and jargon, and neither side seemed to make much, if any, attempt to communicate with the other. In the world of mid-twentieth century origami, the situation might,

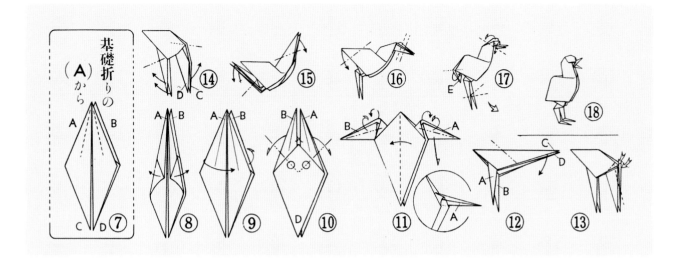

基礎折りの
（A）から

Fig. 61
**An example of
Yoshizawa's
diagrams, from
*Origami Dokuhon I***
Courtesy of Mrs.
Kiyo Yoshizawa

at first glance, appear even more troublesome. Origami practitioners not only came from wildly diverse backgrounds—ranging from a Japanese metal-worker steeped in tradition and religion to an Argentinean circus knife-thrower—but folders spoke truly different languages! At least scientists and humanists at Cambridge all spoke some version of English. The innovators who would develop modern origami were diverse, both geographically and linguistically.

And yet, thanks in large part to Yoshizawa, origami aficionados did have a common language for origami instruction. Yoshizawa developed a pictorial system of conveying folding sequences, breaking each figure down into a series of steps and marking the desired actions with dotted lines and dashed arrows. The use of step drawings for origami instruction was itself not new; a mid-nineteenth century Japanese text,

the *Kayaragusa*, contained stepwise instructions for several of the traditional origami folds. They showed progressive stages of the folding process and left it to the reader to determine how to get from one step to the next. What was new about Yoshizawa's diagramming system was the focus on the *action* in each step. His drawing did not just show the result of the previous step, it also clarified visually *what had to happen* in order to advance to the next step. Yoshizawa introduced dashed lines (for valley folds) and chain lines (for mountain folds) to relate the positions and directions of the folds. He also employed several types of arrows in his diagrams to illustrate which parts of the step moved and in what direction (see fig. 61).

Other Japanese origami masters of the mid-twentieth century used their own instructional notations—either derived from Yoshizawa's model or

developed as a competing system. However, it was Yoshizawa's notation that was adopted by two of the early English-language authors of origami, British magician Robert Harbin and American author Samuel L. Randlett (though each made small adjustments to the system). Whether it was due to the clarity of Yoshizawa's diagrams, the beauty and force of his origami creations, or simply an accident of history that his notation was adopted, the impact of a series of publications on three continents all using essentially the same notation proved irresistible. The Yoshizawa-Harbin-Randlett notation for diagramming origami has subsequently become standard and ubiquitous in the modern world of origami instruction, and in the 1960s it kick-started the world of origami creativity.

An essential feature of Yoshizawa's instructions was that the diagrams themselves were usually sufficient to convey

the action to be performed at each step independently of any accompanying text. This property became one of the hallmarks of "good diagrams"—that words were not necessary for their comprehension. And this practice, as much as anything else, led to the exponential growth and creativity that origami experienced over the last 50 years of the twentieth century. It enabled American folders to learn from Japanese, French from Americans, Spanish from French, and Japanese from Spanish. Each could learn from the other, build upon the other's accomplishments, and then pass knowledge on to the next folder. The ability to communicate cross-culturally led to an *ethic* of sharing concepts and ideas. The worldwide growth of folding featured several famous disputes over priority of invention—Honda *v.* Yoshizawa, Yoshizawa *v.* Cerceda, Sagredo *v.* Montoya—but those, by and large, faded away in the 1970s and 1980s. Origami artists dealt with questions of priority simply by letting everyone else know how their figures were designed and folded. The Yoshizawa-Harbin-Randlett notation made that sharing both feasible and efficient.

EVOLUTION

The 1970s through 1990s were years of great progress in the world of international origami. Rapid advances were made in folding techniques, range of subject matter, and complexity of those works at the leading edge of origami design. Widespread publication of ori-

gami magazines and convention books, by now almost entirely standardized in their pictorial language, led to rapid communications of new developments. But even so, a "Two Cultures"-type conflict was brewing within the world of origami. Although aspects of this conflict were mirrored in the West, it was in Japan, the cradle of origami, that the conflict was thrown into starkest relief.

Yoshizawa's work and that of his fellow origami masters in Japan was neither widely known within the country, nor considered typical of twentieth century origami by most of the Japanese populace. In fact, although the national pastime of origami had been adopted into the Japanese school curriculum in the twentieth century (ironically, largely through the efforts of a foreigner, the German educator Freidrich Fröbel), the origami known to most Japanese was simple, "cute," and pursued largely by women. It was not held in high regard. In fact, creating the raw material for origami—paper making—was held in much higher regard than the origami art itself! One can speculate how much of the low esteem of origami was tied to its primary practice by women (or vice versa); but it is clear that the popular impression of origami was not very high, and the emphasis on "simple and cute" origami extended to the Japanese national origami society, the Nippon Origami Association (NOA), whose magazine, with few exceptions, focused on simple figures like flowers and toys.

Within the Japanese origami community, though, there were a small number of men—and women—who were not content to continue developing variations on the traditional subjects. Their desire was to push the state of the art, to create figures that not only had never before been folded, but figures that everyone thought would be *impossible* to fold. They began convening on their own to share ideas and goals and to actively goad each other onward to ever-more challenging targets. They called themselves the *Origami Tanteidan,* or "Origami Detectives" (a translation that better conveys the meaning of this group's name would be "Origami Investigators"). While Japanese individuals were exploring and advancing origami throughout the 1980s, in 1990 the *Origami Tanteidan* formally created their own organization, now known as the *Japan Origami Academic Society*. Members of the *Tanteidan* pushed the limits of the art, but they did something more, which some traditionalists would consider nearly heretical – they began to study the geometric and related mathematical laws that made origami possible.

The *Origami Tanteidan* had kindred spirits, though not an entire kindred organization, in the Western world of paper folding. And sometimes, the parallel identity extended to specific ideas and discoveries. One of the first in the new generation of Japanese folders to come to the attention of the West was Jun Maekawa, whose complex and

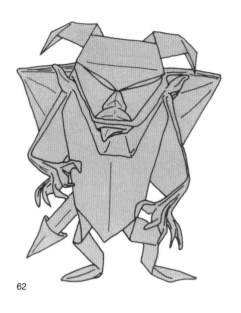

62

63

stunning "Demon" graced the cover of his debut book, *Viva Origami* (1983), by Kunihiko Kasahara (fig. 62). Maekawa's work was a distinct jump in complexity from what came before, and he achieved his designs by using a novel technique of splicing together patches of existing origami patterns in new ways to realize far larger, more complex structures than anyone had achieved to date. And yet, he had a counterpart—American architect Peter Engel, the same age, had developed his own similar splicing technique, yielding work of equal complexity and remarkably comparable structure (fig. 63).

This was a phenomenon more typical of the sciences than the humanities: that of simultaneous invention. It is generally assumed in the humanities that if two artists produce substantially the same work, one must have influenced by the other. The creation of a piece of art is considered a unique accomplishment by a unique human being. No two artists are alike.

In the sciences, though, and in mathematics in particular, there is a general belief in the existence of an objective reality that investigators are merely discovering. Cases of simultaneous discovery are common and legendary: Darwin and Wallace with the theory of evolution, Newton and Leibniz with the description of calculus. In origami, though, how could there be simultaneous creation of an origami figure? If simultaneous creation is found, then would origami be more of an art, or a science? If one used techniques for the creation of origami that could result in simultaneous independent creation by two different artists, then could the result even be considered art at all? Or is it no more art than, say, a mathematical theorem?

This conundrum came to affect me, too. Although I had been an avid practitioner of origami since the late 1960s, cutting my teeth (but not my paper) on the works of Yoshizawa, Harbin, Randlett, and those artists described within their books, this blurring of the boundaries of art and science in the vicinity of origami was most strongly brought home to me by an event in the early 1990s. By then, having developed a few hundred original designs of my own and having had several books of my work published, I was invited to Japan to address the annual meeting of the Nippon Origami Association—through the strong support of friends in the *Origami Tanteidan*, then in the process of budding off to form their own society. One of the origami subject areas I had

become known for (or notorious for, depending on who you asked) was insects, for years regarded as the most challenging origami subject matter to take on. In fact, some early origami artists had stated that origami insects were impossible to fold from a square sheet of paper, but I and my counter-parts in the *Origami Tanteidan* devoted a substantial fraction of our efforts to proving them wrong with multi-legged origami creations of all types.

Over the preceding decade or so I had developed a concept for the creation of multi-legged creatures that was particularly powerful: it involved representing each leg, wing, or antenna of the subject by a circle, representing body segments by movable spacers, and then finding an arrangement of these geometric objects on a square, and using the resulting pattern as the basic framework of an origami figure. During a quiet moment at the NOA convention where I was to make my address, I began doodling the design of a new beetle. One of my *Tanteidan* hosts, looking over at my pad of paper, smiled knowingly and said, "I know what you're doing! Meguro does exactly the same thing!"

This was a bit of a surprise: I have mentioned that there was a general culture of sharing techniques in origami and I had shared many of my designs, but I hadn't gotten around to figuring out the words to describe exactly what I was doing with these circles, and so, hadn't yet shared it with anyone—let alone someone in Japan! Who was this mys-terious Meguro, and how had he found out "my" technique for origami design, which I called "circle packing?"

CIRCLE PACKING

To give a hint of how that might have happened, let me pause in the narra-tive to describe the basic idea of circle packing as applied to the design of an origami insect (or any other shape with multiple appendages). Such a figure can be viewed as a collection of appendages, and the first challenge in folding a design with a lot of ap-pendages is making sure that there is enough paper for every appendage. If one is folding a six-legged beetle from a square, for example, one can fairly easily fold a four-cornered square into a four-appendaged shape; but then you've used up all the paper, and there's nothing left to make the other two appendages.

So the first big question to consider is: how much paper does an origami appendage take up? By append-age, I mean an arm, leg, wing, jaw, or antenna—or, in general, a "long, skinny shape." It doesn't really matter what the specific type of appendage is; if it's long and skinny, one can make it from a long, skinny bit of paper. And in origami, we call such a long, skinny bit of paper a "flap." Thus, the question of designing an origami figure can be boiled down to the problem of creating a collection of flaps with the right number, length, and connectivity of flaps. And the question of allocating paper for appendages hinges upon the answer to a very basic question: how much paper does it take to make a long, skinny flap?

What makes origami design challenging is that the answer to this question is, "it depends." It depends on the length of the flap (which is not terribly surprising). But it also depends on which part of the paper the flap comes from.

And this we can easily visualize with a few thought experiments. Suppose we were making only a single flap. This is done most quickly by folding the square along a diagonal, then folding it again and again (as if making a paper airplane) to make it skinnier and skin-nier, as shown in fig. 64 (page 68). At some point, we can declare "enough" with the narrowing folds and then fold a crease to form the boundary of the flap, separating what paper is "flap" from what paper is "everything else." Then, if we unfold the paper, we can find the boundary crease and use that to see what paper went into the flap. As the figure shows, for this particular flap, the amount of paper that was needed was a quarter of an octagon, centered on the point that is the tip of the flap.

What if we make the flap skinnier? By folding the paper in half once more, we see that the boundary of the flap be-comes a quarter of a 16-gon, and so it takes up slightly less paper. That shows that the skinnier the flap is, the less paper it consumes. And so, what if we take it to the limit: what is the amount of paper needed for the skinniest possible

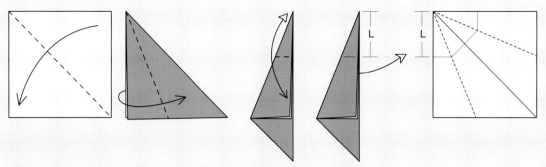

Fig. 64. Folding of a single flap of length L. The quarter-octagon in the upper left of the crease pattern shows the paper needed to make the flap.

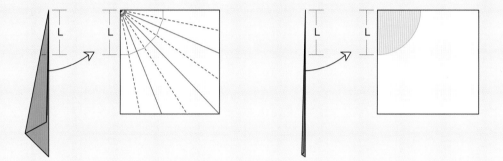

Fig. 65. Left: a skinnier flap requires a quarter of a 16-gon. Right: The limiting case of an infinitely skinny flap requires a quarter-circle of paper.

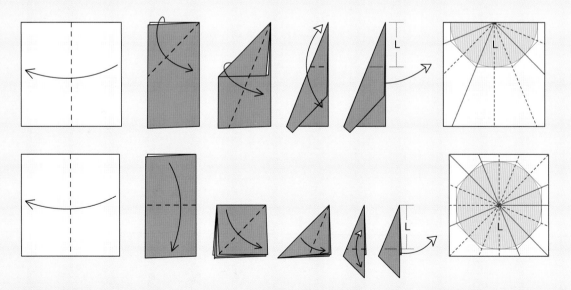

Fig. 66. Edge and middle flaps require, respectively, a half-circle or a full circle of paper.

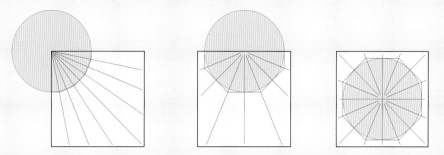

Fig. 67. Unification. In each case, the partial circle can be considered the result of an overlap between the square paper and a full circle, whose center is confined to remain within the square.

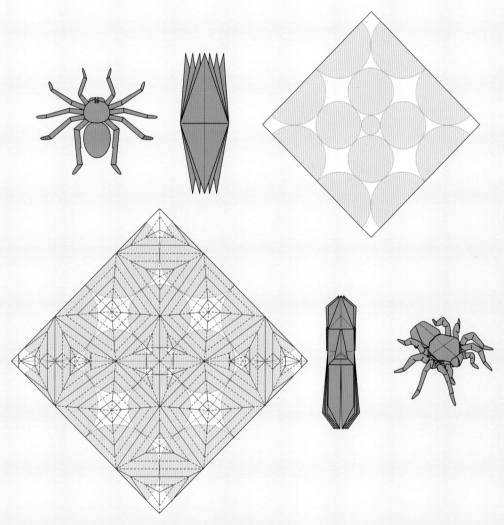

Fig. 68. The full progression. Top row: desired subject, hypothetical collection of flaps, and the circle packing. Bottom row: the full crease pattern, the actual base, and the finished origami figure.

flap of a given length? And, as fig. 65 (page 68) shows, in the limiting case, the minimum amount of paper needed is a quarter circle.

Now, we made this flap from the corner of the square, but if we're planning to make a six-legged beetle, we can't have all flaps come from the corner of the square. So we need to consider flaps that come from other regions. We can carry out exactly the same thought experiment (or real paper experiment) for a flap whose tip comes from the edges of the square and, as fig. 66 (page 68) shows, the minimum amount of paper needed is a half-circle. And if the flap comes from somewhere in the interior of the square, the minimum amount of paper needed is a full circle.

In fact, we can recognize that these three situations are just special cases of a general idea: that no matter where a flap comes from on the paper, the paper that it consumes is the overlap between the square and some *full* circle whose center is constrained to lie within the square, as shown in fig. 67 (page 69). And the radius of the circle is exactly the length of the desired flap.

And this provides the key insight for designing figures that have *multiple* flaps. Each flap will consume a circular (or part-circular) region of paper; and the individual regions can't overlap (because the region of overlap would end up in two different flaps, two different places at once—not possible). So, one could design an origami shape with any

number of flaps of any length, simply by finding an arrangement of circles on the square—not unlike packing round cans in a square box.

The key to the puzzle of origami design was finding the right packing of circles on top of the square; once one had that, it was a relatively straightforward process (not simple, but straightforward) to find the creases that would allow one to fold the paper into the origami shape. Finding and folding the creases that go with a given packing was, and remains, difficult; but once you have the packing, eventual success is guaranteed. And that is a considerable help to an origami designer (fig. 68, page 69).

So that was the circle packing that I was doing in Japan in 1992—and, as it turned out, that was also the circle packing that had been discovered completely independently by Toshiyuki Meguro, a Japanese biochemist, and used for an astonishing range of his own insect designs (as well as many other elegant origami creations). Before the trip was over, we had gotten together through the efforts of our host. And though I spoke no Japanese, and he spoke almost no English, we both spoke origami, and more importantly, perhaps, we both spoke mathematics, the shared language of our technical fields (him: biochemistry; me: physics).

Though we approached origami as artists, we came from the world of science and were comfortable with mathemat-

ics, the language of science and an essential component in the toolkit of engineering. Though Meguro and I never talked about the process that led him to his understanding of circle packing as applied to origami, my own development of the technique was a long, drawn-out process. It proceeded from (what now seems) a dim understanding that flaps needed a certain amount of paper all to themselves, advancing towards the realization that a circle seemed to describe the amount needed, and eventually culminating in a precise mathematical description of the design process in which the mathematics led naturally and directly to a description in terms of packing circles.

INVENTION OR DISCOVERY?

In many fields—science, engineering, humanities, religion—there is the phenomenon of the intuitive leap, the stroke of insight. In science, when the technical papers get written, the development of the big idea is typically presented as proceeding inexorably from fundamental principles and deduction from observations. But what is, perhaps, the dirty little secret of many working scientists—and certainly, many working origami artists—is that the intuitive leap comes first and why we do what we do can't necessarily be put into words. What sets science apart from other fields is that we have mathematics at our disposal: once we have the idea, we can go back and work out a clean derivation and/or a comparison with observation, hopefully confirming

Lang's crease patterns (right) are maps of the major folds of his designs and use colors to represent different roles of the folds and the relative orientation of different regions of the paper.

70

Fig. 69
Emperor Scorpion HP, opus 593
Robert J. Lang (American), USA, 2011, one uncut square of Korean *hanji* paper
Photo courtesy of the artist

Fig. 70
Crease Pattern for Emperor Scorpion HP, opus 593
Robert J. Lang (American), USA, 2011, giclée print on canvas
Courtesy of the artist

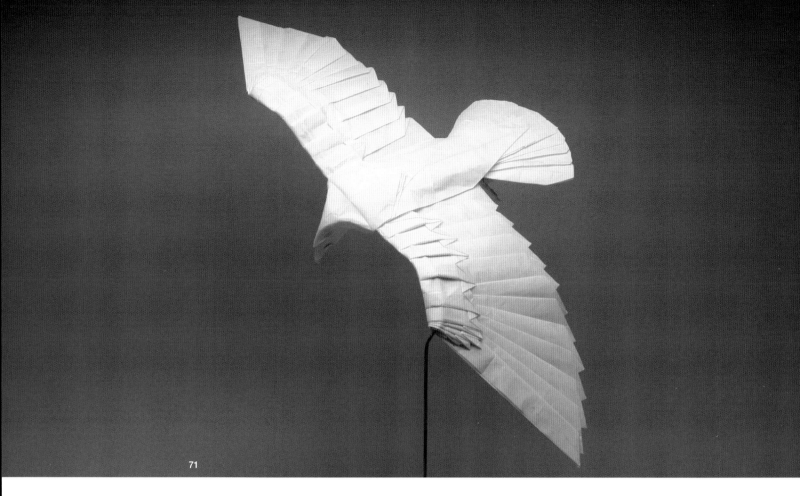

71

Fig. 71
Soaring Red-Tailed Hawk, opus 601
Robert J. Lang
(American), USA,
2011, one uncut
square of Korean
hanji paper
Photo courtesy of
the artist

Fig. 72
Crease Pattern for
Soaring Red-Tailed
Hawk, opus 601
Robert J. Lang
(American), USA,
2011, giclée print on
canvas
Courtesy of the artist

72

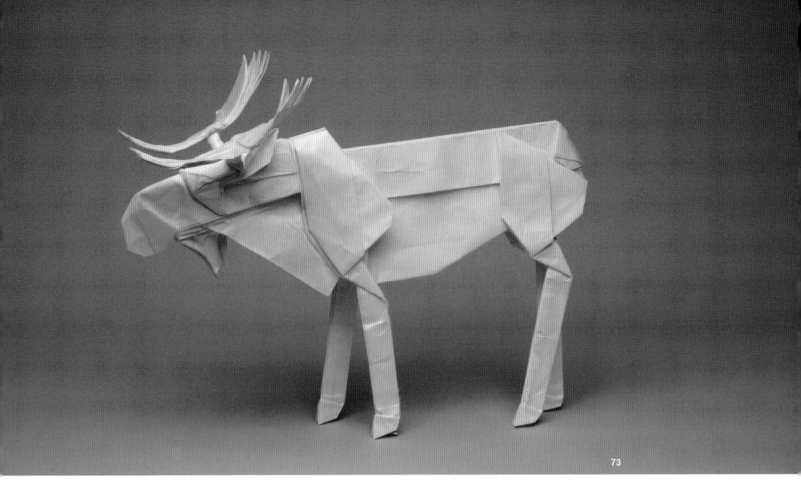

Fig. 73
Bull Moose, opus 413
Robert J. Lang (American), USA, 2011, one uncut square of Korean *hanji* paper
Photo courtesy of the artist

Fig. 74
Crease Pattern for *Bull Moose, opus 413*
Robert J. Lang (American), USA, 2011, giclée print on canvas
Courtesy of the artist

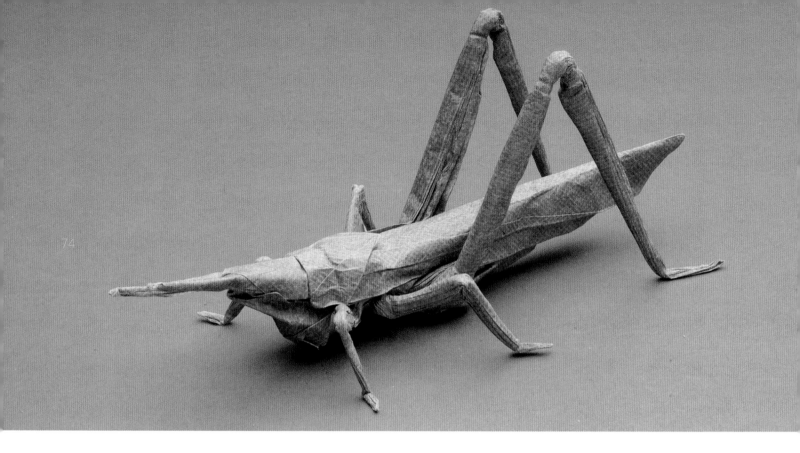

74

Fig. 75
Grasshopper
Brian Chan (Chinese
American), USA,
2011, handmade
Origamido Paper

our hunch, or, if not, revealing its limitations. In the case of origami design, mathematics not only confirmed a set of hunches about packing circles that were a crude design guideline: it provided tools that let us hone this crude guideline into a powerful and broad set of techniques that let us specify precisely the shapes we wanted—and then design and fold them.

It seems that the concept of circle packing and its associated mathematical description was there all along as part of origami, waiting to be discovered. Both Meguro and I went on to describe our respective techniques in a range of publications, both origami-related and computer-related (because

the associated algorithms can be described as computer algorithms) and the original concepts of circle packing have been fleshed out in the subsequent decades by ourselves and others, to the point that there is now a rather extensive toolkit of techniques for origami design that are used by artists from all over the world to create forms that have been described as "mind-boggling"—all the more so when one considers that they are all nothing more than folded deformations of an uncut sheet (fig. 75).

One question remains, though: in the 300-plus years of origami's existence, how is it that two independent folders would come up with the same special-

ized concept within a few years of one another, working entirely independently?

And the answer, I think, is that nothing is truly independent. Meguro and I each built upon the work of our predecessors: Maekawa and Engel, who I have mentioned, and origami artists before them, including John Montroll, one of the great American masters who created truly remarkable and complex works in the 1970s, and a mentor of mine, Neal Elias, who challenged and inspired me as a teenager with sophisticated multi-appendaged figures. Neither of them used circle packing to design their figures, though both designed elegant and complex artworks. Why did circle packing occur to me and

not my predecessors? What I had that 300-plus years of prior origami artists did not was an enormous assortment of complex origami works to study, examine for common structures, and try to generalize from. And the reason I had those works was that Yoshizawa, Harbin, and Randlett had popularized origami to a worldwide audience. And their success in that popularization was due to the language created by Yoshizawa for its propagation.

Once the genie of circle packing and mathematical origami was released, though, there was no stopping it. Origami artists from around the world began to use these techniques, and—taking another page from the playbook of science—to expand upon them, to develop them further, to refine and combine and mix and match in ways that neither Meguro nor I had even imagined.

APPLICATIONS

Mathematics, when it came to origami, put a bevy of new tools into the hands of origami artists. But it did more: those same tools could be wielded for purely functional purposes. The ability to model and analyze folding mathematically meant that engineering problems that involve folding could be addressed with those same mathematical tools—and sometimes, could be solved with the exact same algorithms that were used to design origami artworks.

The circle packing gives the allocation of paper for each flap; it doesn't tell

you where the folds go, at least not directly. There was more to be discovered beyond circle packing, such as figuring out how to turn a circle packing into a crease pattern. In the packing, the centers of circles turned out to be key points in the crease patterns with creases connecting centers of touching circles, but those creases were merely the skeleton of the desired pattern. To complete the rest of the pattern required filling in gaps in the pattern with small, building-block crease patterns— a concept dubbed "molecules" by Meguro. The name was coined by Meguro, but several folders discovered members of the family of molecules over a period of years: Meguro, Maekawa, Kawahata, and myself all found molecules that could be used to build up complete crease patterns.

Most origami molecules worked for a few specific shapes: triangles, perhaps, or certain quadrilaterals. In the mid-1990s, I developed an algorithm that could

construct a molecule that worked for any polygon whatsoever that might appear in a circle packed origami design. I called this algorithm and the resulting pattern the "universal molecule," and used it in a wide variety of origami designs.

Mathematical algorithms do not care what they are used for, art or science. And so, a few years later, a software company attempting to simulate the flattening and expansion of automotive airbags contacted me. Those who design airbags have a big problem to deal with—their product needs to work whether the car is going fast or slow; whether the occupant is sitting close to or far from the airbag; whether the impact is front, side, or off-center; and a host of other variations. The only way to insure that the airbag provides the right cushioning force under all conditions is to either crash a lot of cars (not very desirable if you're designing an airbag for a Lamborghini), or to run computer simulations.

Fig. 76
Airbag Deployment Video
Robert J. Lang (American), USA, digital video; 8 seconds
Illustration courtesy of the artist and Rainer Hoffman

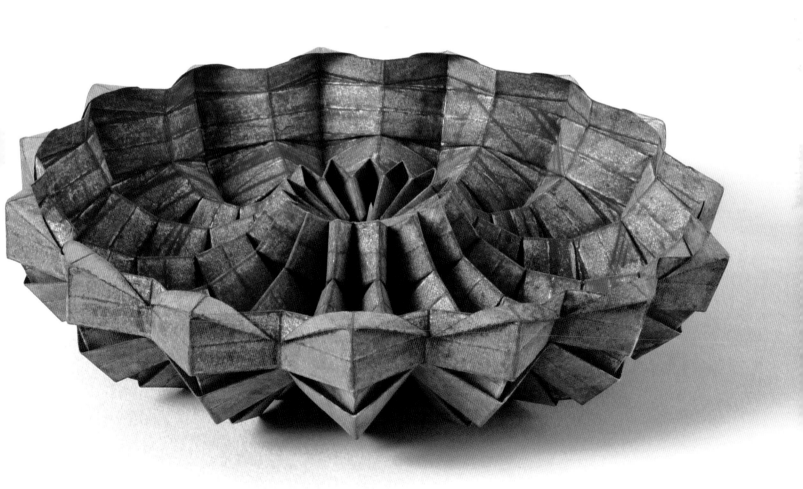

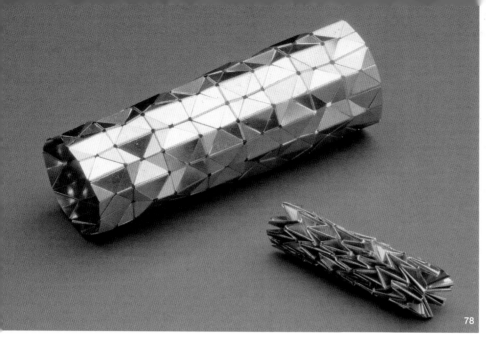

78

79

But the simulations hit a snag. While an airbag is designed with the inflated shape of the airbag in mind, the simulation must start with a flattened and folded airbag. Such a simulation is carried out using finite-element analysis, in which the airbag is represented by a fine mesh of triangles, and for technical reasons in the simulation, the lines of the mesh needed to follow the fold lines when the bag is flattened. These fold lines were unknown, and would be different for every single airbag or design variation. So the airbag designers had a very well defined problem: "What are the fold lines needed to flatten an arbitrary, polyhedral airbag?"

That problem, unique to airbags, is rather close to another problem, unique to origami: "what are the fold lines needed to flatten an arbitrary polygon?" In fact, they are very close indeed: a polyhedral airbag is nothing more than a collection of polygons in 3D. With a

few modest changes, the "universal molecule" of origami insect design could be, and was, adopted by airbag designers to give the folding pattern for the flattening, and eventual complete simulation, of new airbag designs (fig. 76, page 75).

Once a problem has been expressed in mathematical form, its mathematical solution can lead to many places. Mathematics is agnostic with respect to its application: it can be used for technological purposes, designing airbags, spacecraft, and consumer electronics (all fields that have made use of the mathematics of origami and folding). The crease pattern of the traditional Waterbomb can be arrayed into a surface whose properties make it ideal for a heart stent (fig. 78). A method for shrinking flaps called an "open sink" can be used to fold up a telescope lens (fig. 79).

But even beyond that, mathematics can be used for art, providing a toolkit to those origamists whose muse takes them in the directions of complexity and structure. The lowest-energy configuration of a stressed thin-plate structure leads to a double-corrugated pattern that, in engineering, is the heart of the Miura-ori pattern used for maps and solar arrays by Japanese engineer Koryo Miura (fig. 80); yet this same structure is also the heart of the organic, abstract forms of British artist Paul Jackson (fig. 77, pages 76 and 77).

BRIDGING

However, a "Two Cultures"-style communication gap has been introduced with the new toolkit of mathematics. The language of this toolkit now inevitably includes mathematics (concepts, and sometimes, actual mathematical notation), and the polarization between

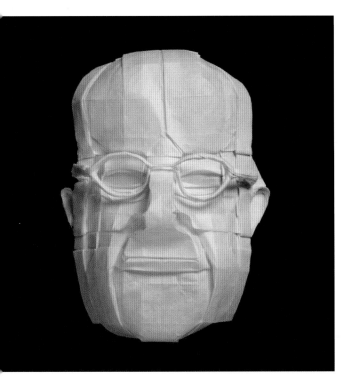

sciences and humanities that exists in academia and in the world at large, cannot help but be found in the world of origami. There are those who eschew the use of geometric design techniques, some for aesthetic reasons, some for fear that by using widely known techniques their work will be drawn toward that of others in a way that diminishes the novelty of their own work. And some artists stay away because, as they put it, "I was never good at math." A perennial late-night discussion topic at origami conventions is "but is it art?" The presence of a heavy dose of mathematical underpinning adds fuel to these flames.

As time passes, though, what once was alien and novel becomes familiar and less intimidating, and the use of mathematical concepts in origami has not led to widespread duplication of work (though the occasional independently created pair still crops up from time to time). Geometric ideas within origami are now generally recognized for what they are: tools for the creation of art—powerful, perhaps, but still just tools wielded by humans in service of aesthetics. And just as some painters might choose to use oil paints and others might prefer pencil, some origami artists use geometric ideas to create their designs, and others continue with a more intuitive, or at least, less structured, approach. Yes, the humanist origami artists talk to each other about line and form, and the mathematical origami artists wax lyrical in their discussions of the latest algorithms, but a fair amount of the time, humanist and mathematical origami artists communicate each with the other, exchanging ideas and furthering innovation. So there are, it appears, some fields where a "Two Cultures" gulf is gradually being filled in. Were C. P. Snow still alive, we might hope he would look on this development with satisfied approval (fig. 81).

"Even DNA is folded—you and I are born from folding."

PAUL JACKSON
Excerpt from *Between the Folds*

ARTIST BIOS

John Blackman
(b. 1955, American)
John Blackman's interest in origami began during his childhood and has grown into a passion. His other pursuits are gardening, nature and Ikebana (the Japanese art of flower arranging), all of which he merges with origami. Today Blackman mainly folds plant and flower forms, often turning them into Japanese-style arrangements. His works have been exhibited at several OrigamiUSA national conventions, libraries and galleries. Blackman's works are featured in *The Art of Origami* by Gay Merrill Gross and *The Encyclopedia of Origami* by Nick Robinson. His website is **origamiflora.com**.

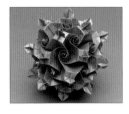

Krystyna and Wojtek Burczyk
(b. 1959 and 1960, Polish)

Krystyna Burczyk has taught mathematics for more than 20 years. In 1995 she began folding paper, exploring the relationship between origami and mathematics through the creation of geometric models. She is also interested in the educational applications of origami, especially in regard to mathematics, and has written five origami books. Her husband and artistic collaborator, Wojtek Burczyk, also started origami in 1995 and has a similar background in mathematics and computer science. Together they promote origami within their community, and participate in national and international origami exhibitions.

Brian Chan
(b. 1980, Chinese American)
Brian Chan studied origami avidly as a child. While pursuing a degree in mechanical engineering at MIT, a visit by Robert Lang in 2004 re-inspired him to take up folding seriously. Now an instructor at MIT and a freelance artist, Chan is considered one of the world's foremost origami

folders. His eclectic range of complex origami forms includes insects, humans, and figures inspired by fantasy and the visual arts. His origami is displayed on the MIT webpage, **web.mit.edu/chosetec/www/origami/**.

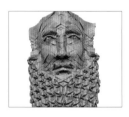

Joel Cooper
(b. 1970, American)
Joel Cooper studied sculpture with an emphasis on bronze casting at the University of Kansas. He enjoyed origami as a hobby since childhood and became very adept at executing the most complicated models, yet had never designed his own pieces. In 2000 he encountered origami tessellation and was attracted immediately to its potential for complexity, savoring the pure mathematical regularity of tessellations. He soon combined the techniques of origami tessellation with his background in sculpture to create a new style of folding complex masks from single pieces of paper. He has exhibited his works and shares them with others on his blog, **joelcooper.wordpress.com.**

Erik Demaine and Martin Demaine
(b. 1981 and 1942, Canadian American)
Canadian-born Erik Demaine completed his Bachelor of Science degree by age 14 and his Ph.D. by age 20. His dissertation, a seminal work in the field of computational origami, received national awards and won him a MacArthur Fellowship. Since joining the MIT faculty in 2001, he has been the leading theoretician in computational origami, the study of what can be done with a folded sheet of paper, and he is exploring origami applications in architecture, robotics, and molecular biology. Artistically, he collaborates with his artist father, Martin Demaine, to create "Curved-Crease" sculptures and other unconventional origami works. His website is **erikdemaine.org**.

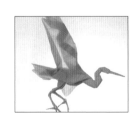

Roman Diaz
(b. 1968, Uruguayan)
Roman Diaz was born in Montevideo, Uruguay, and lived in Argentina, Honduras and Mozambique as a child. During his travels Diaz occasionally experimented with origami. He returned to Uruguay, completed his studies and became a veterinarian. Fascinated by the possibilities of origami, he started designing his own models. By 2005 his designs of animals were attracting international attention. Since then he has been a special guest at origami conventions in Spain, France, Italy, Germany and Chile and has published two books.

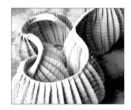

Christine Edison
(b. 1975, American)
Christine Edison is a teacher and paper folder based in Chicago. She started folding seriously around 2003 and since 2006 has been specializing in tessellations. Her work varies from intricately detailed tessellations to bold sculptural pieces. She blogs about her origami

and other interests at
cedison.wordpress.com.

Vincent Floderer
(b. 1961, French)
Vincent Floderer has moved
away from conventional
origami and has developed
a whole new vocabulary of
techniques, most famously
crumpling. The inspiration
for his crumpling came
originally from English
folder Paul Jackson, but he
has developed Jackson's
ideas further and has
evolved methods—includ-
ing dampening and stretch-
ing—that have allowed him
to create organic forms
such as mushrooms and
toadstools and multi-lay-
ered forms such as corals
and sponges. Turning
paper inside out has also
resulted in organic abstract
creations. His website is
le-crimp.org.

Tomoko Fuse
(b. 1951, Japanese)
Tomoko Fuse first learned
origami while in the hospital
as a child. She is widely
considered one of the
world's pre-eminent modu-
lar origami artists and has
designed many modular
boxes and containers,
polyhedra and other geo-
metric objects, as well as
kusudama (balls made by
sewing or gluing together
separate, usually flower-
shaped, units), paper toys
and masks. Since the early
1980s she has published
over 60 books in Japanese,
Korean and English.

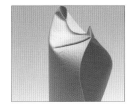

Giang Dinh
(b. 1966, Vietnamese
American)
Giang Dinh was born in
Hue, Vietnam. He studied
architecture in Vietnam and
in the United States and cur-
rently lives in Virginia, where
he works for an architectural
firm. He started creating ori-
gami in 1998 and is now well
known for his simple and
elegant designs infused with
a zen-like spirituality. Rather
than crisp, sharp folds,
which he compares to ink,
he chooses soft folds, which
are like pencil lines. He often
works in plain white paper so
that the viewer can concen-
trate on the pure form and
shadow of the work. Many
of his works are wet-folded
and have the appearance of
semi-abstract sculptures. His
website is giangdinh.com.

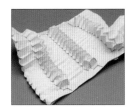

Eric Gjerde
(b. 1978, Norwegian
American)
At age five, Eric Gjerde
wanted to be "a paperolo-
gist," and growing up, he
enjoyed paper crafts and
origami. After preparing
for a technology career,
Gjerde kept looking for an
artistic outlet to balance his
creative side with his pro-
fessional life. He returned to
his childhood love of paper,
and currently focuses on
the geometric art of origami
tessellations. He teaches,
exhibits his works, and has
written *Origami Tessella-
tions: Awe-Inspiring Geo-
metric Designs* to introduce
readers to the incredible
beauty and diversity of
origami tessellations. His
website is
origamitessellations.com.

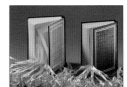

Miri Golan (b. 1965, Israeli)
Miri Golan is probably best
known for the educational
work she does in Israel, us-
ing origami to unite people
of different religious and
cultural backgrounds. Her
students often create gar-
lands of origami cranes as
a wish or prayer for a more
peaceful world. Golan,
who is married to English
origami artist Paul Jackson,
also creates conceptual
pieces, such as *Two Books*,
in which origami figures
emerge from the pages
of two sacred texts, the
Torah and the Koran, and
reach out to each other.
More information about her
educational programs can
be found at
foldingtogether.org.

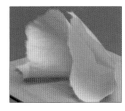

Koshiro Hatori
(b. 1961, Japanese)
Koshiro Hatori is a profes-
sional translator and
origami artist who has
made significant contribu-
tions to the academic study
of origami. His research has
led to breakthroughs in the
mathematics of origami as
well as the history of this
art form both in Japan and
the West. His designs range
from traditional origami
to abstractions, crumpled
forms to pleated sculptures.
His website is
origami.ousaan.com.

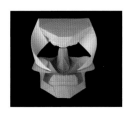

Herman van Goubergen
(b. 1961, Belgian)
Belgian folder Herman van
Goubergen is a computer
programmer and has been
creating origami since
he was 14 years old. His
designs are known for their
playful trompe l'oeil qual-
ity, as they are not always
what they first appear to
be. He creates new works
infrequently, and each piece
is scrupulously based on a
novel origami concept that
challenges conventional
notions of folding. In all his
projects van Goubergen
seeks to create a work that
encapsulates and dem-
onstrates the innovative
concept he is exploring.

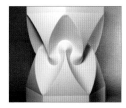

David Huffman
(1925–1999, American)
David Huffman was an elec-
trical engineer best known
for the invention of the Huff-
man code, a compression
scheme which enables the
consolidation and transmis-
sion of digital data, used
in fax machines, modems,
computer networks, and
high-definition television
(HDTV). Dr. Huffman was
also a pioneer in develop-
ing the mathematics of
origami, including 3D poly-
hedral and curved forms.
In contrast to traditional
origami, which was primarily
representational and used
straight folds only, Huffman
developed abstract and
geometric structures based
on curved folds, inspiring
artists Erik and Martin De-
maine and Jeannine Mosely,
among others.

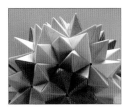

Tom Hull
(b. 1969, American)
Tom Hull is an associate professor of mathematics at Western New England University in Massachusetts. He is known as a preeminent authority on the mathematics of paper folding. Hull's own research has developed some of the mathematical foundations of origami, and his historical analysis has uncovered previously neglected mathematical origami contributions by other scholars. His passion for teaching often combines origami and mathematics, and he regularly teaches origami math to classes ranging from high school to advanced college seminars. His book, *Project Origami*, explains how origami can be used to teach math – not just geometry, but also calculus, abstract algebra, topology, and more. His origami works, which are mostly modular forms, display the intersection of mathematics and art.

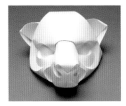

Roy Iwaki
(1935–2010, Japanese American)
Roy Iwaki was born in Los Angeles and was six years old when war broke out with Japan and he was sent with his mother and older siblings to the Manzanar Relocation Camp. After the war he enlisted in the Air Force and then went on to study architecture. Before starting his career, he visited Japan, and developed an admiration for Japanese art, including woodblock printing and origami. After two years as an architect, he relinquished that career to pursue his passion for working with his hands. Iwaki first created his origami masks in the late 1960s and was making these and other works of art until his death in 2010.

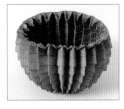

Paul Jackson
(b. 1956, British)
Paul Jackson's childhood hobby was origami. After art school in London, he taught folding techniques, wrote books about paper art, and in the 1990s started exhibiting his origami. In 2000 he met Israeli artist Miri Golan and relocated to Israel, where he now teaches at art and design colleges. In contrast to the complex, detailed origami of many artists, Jackson's paper sculptures aspire to be "simple, elegant in sequence and form, surprising in concept and even audacious." He prefers forms that appear to have been "discovered" in the paper, rather than "contrived" from it. His website is **origami-artist.com**.

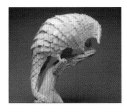

Eric Joisel
(1956–2010, French)
Eric Joisel was widely regarded as one of the most talented origami artists in the world. A sculptor with a background in history and law, Joisel was inspired by the works of Yoshizawa to turn his hands to origami. Largely self-taught in origami principles, he combined design techniques like box-pleating, folding techniques such as wet-folding, and tools he seamlessly adapted from his sculptural background to create figures and animals that appear sculpted or molded rather than folded. Joisel turned single uncut sheets of paper into wondrous creations. He excelled at animals, whimsical fantasy figures such as dwarves and wizards, and masks, sometimes depicting the faces of fellow origami enthusiasts. Before he died, he was working on a group of meticulously costumed characters from the Commedia dell'Arte. His work can still be enjoyed on his website **ericjoisel.com**.

Satoshi Kamiya
(b. 1981, Japanese)
Despite his young age, Satoshi Kamiya is one of the most advanced origami folders in the world. He started folding paper at age two and began designing more sophisticated models at age 14. At age 17, he was invited onto a Japanese game show, "Origami TV Champion," where he won the competition against artists twice his age, and proceeded to do so for the next three years straight. He has made hundreds of origami models, drawing inspiration from nature, Eastern and Western mythology, *manga* and even video game characters. Many of Kamiya's origami designs are exceptionally complex—some of his dragons require around 275 steps—while others, such as his Eastern Dragon, which took 40 hours to fold, are so complex that they will likely never be diagrammed for instruction.

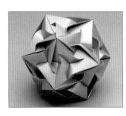

Miyuki Kawamura
(b. 1970, Japanese)
Miyuki Kawamura began origami at the age of two and has been folding paper since then. She is a well respected folder in Japan and is a board member of the Japan Origami Academic Society. Kawamura has a background in physics and specializes in modular origami. She has published several books about origami including *Polyhedron Origami for Beginners* in 2002 and has exhibited her work internationally.

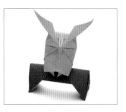

Hideo Komatsu
(b. 1977, Japanese)
Hideo Komatsu began folding origami at the age of three and became passionate about it in elementary school after reading the book *Viva Origami* (1983) by Kunihiko Kasahara, which featured works by Jun Maekawa. He later became a member of the Japanese group *Tanteidan* (Origami Detectives) and has been very actively involved in their publication *Oru* (*Fold*). In 1998, he was invited to be a guest folder at the OrigamiUSA Convention, which took him overseas for the first time. His works, mostly elegantly stylized animal forms, have been featured in several international exhibitions.

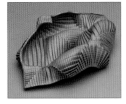

Goran Konjevod
(b. 1973, Croatian American)
Goran Konjevod is a mathematician and theoretical computer scientist who originally practiced origami as a hobby. In 2005, he began creating his own designs. His pieces are mostly abstract shapes formed by tension in the paper when multiple layers are arranged according to their regular or

irregular patterns. Their final forms are, in a sense, organically discovered rather than invented or designed. Although he generally works with single uncut sheets of paper or other foldable material (such as copper) and for the most part employs very simple folds, he also creates three-dimensional forms using multiple layers of thicker paper. Konjevod's work has been featured in exhibitions throughout the United States, Canada, Spain and Croatia. His website is organicorigami.com.

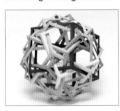

Daniel Kwan
(b. 1986, Chinese American)
Daniel Kwan started folding origami at age five in Chinese school and avidly studied origami books by Tomoko Fuse and others. He has been attending OrigamiUSA conventions since 1997, and in around 2002, he began designing his own modular origami pieces. He has developed a specialty of using edge-based modules to weave together various polyhedra compounds (of which the two models in this exhibition are examples). As of 2008, he has expanded his focus in the origami world to include tessellations.

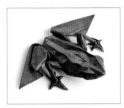

Michael G. LaFosse
(b. 1957, American)
Michael G. LaFosse is internationally regarded as one of the world's top origami masters. He has been practicing origami for more than 40 years and has been teaching it for over 30 years. LaFosse, a master paper-maker, and his partner, Richard Alexander, also create handmade origami paper, known worldwide under the name "Origamido Paper," which they use for their own work and is also sought after by many other origami artists. Together, LaFosse and Alexander have written numerous books on origami. A biologist by training, LaFosse skillfully uses the wet-folding technique and his own specially made papers to create dynamic representations of the natural world. His website is origamido.com.

Robert J. Lang
(b. 1961, American)
After 30 years of studying origami as his passion, Dr. Robert J. Lang gave up his day job as a laser physicist to focus on both the art and science of origami. He is now one of the most respected origami artists in the world and uses his background in science and mathematics to design complex and lifelike forms from uncut squares of paper. Although

Lang uses mathematics (and even, on occasion, computer programs) in his work, he has developed many design techniques that require no more than a pencil and paper. Lang teaches classes and workshops on the techniques he invented, and his book, *Origami Design Secrets*, is considered one of the seminal references for origami design. Lang lectures widely and has collaborated with other scientists, doctors and engineers to apply his knowledge of folding to the design of airbag deployment software, space telescope optics and medical devices. His website is langorigami.com.

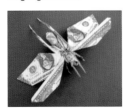

Sipho Mabona
(b. 1980, Swiss/South African)
Sipho Mabona, of Swiss and South African background, was five years old when he folded his first paper airplane. Since then, Mabona's origami has covered a great range of different styles, from very intricate, representational designs to abstract geometrical shapes. Recently, he has created a number of thought-provoking origami installations, bearing powerful social messages about environmental destruction and the dangers of consumerism. He also designed origami for the award-winning Asics corporate movie *Origami in the Pursuit of Perfection*, which

is featured in this exhibition. His website is mabonaorigami.com.

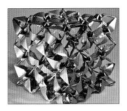

Linda Tomoko Mihara
(b. 1959, Japanese American)
Linda Tomoko Mihara learned origami at the age of six from her grandfather Tokinobu Mihara, author of *Origami-Japanese Art of Paper Folding*. Mihara is best known for her work with folded cranes, in particular her three-dimensional origami sculptures. She is an expert in the *roko-an* technique, in which multiple cranes are folded from a single sheet of paper. This style was based on a series of two-dimensional works illustrated in the eighteenth century book *Hiden Senbazuru Orikata* (*Secret Folding Methods for One Thousand Cranes*). Mihara created her works, *Crane Cube* and *Peace Sphere*, after developing this technique for many years. *Roko-an* is demanding for both the artist and the paper; it took five years to find the right type of paper to realize the *Peace Sphere*, a free-standing, round sculpture. Her website is origamihara.com.

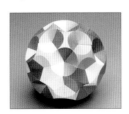

Jeannine Mosely
(b. 1953, American)
Jeannine Mosely has loved origami since the age of five. A graduate of MIT with a Ph.D. in electrical engineering and computer science, she has pursued a career in three-dimensional modeling. Best known for her Menger sponge, a cube measuring 1.5 meters (5 feet) on one side and made from 66,048 folded business cards, Mosely believes that folding origami structures is a way of giving life to a mathematical theorem or formula. Her recent origami work focuses on folding curved lines, both in modular forms and tessellations.

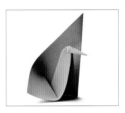

Paulo Mulatinho
(b. 1956, Brazilian)
A native of Brazil, Paulo Mulatinho studied graphic and industrial design in Rio de Janeiro. He has been folding origami for over twenty years and has lived in Germany since 1985. Paulo Mulatinho is the founding president of Origami Germany. He has written several books about origami in English and German and has exhibited his works internationally.

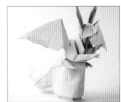

Jared Needle
(b. 1987, American)

One of the younger artists featured in the exhibition, Jared Needle has been folding paper since he was a child and has recently begun exhibiting his own designs at national conventions and exhibitions. Many of his works are inspired by the world of fantasy and the supernatural, in particular the characters featured in anime and video games.

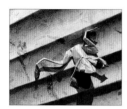

Bernie Peyton
(b. 1950, American)

Bernie Peyton has a background in wildlife biology and spent many years conducting field research and conservation on endangered species, including spectacled bears in the Andes. In the late 1990s he revived a childhood interest in origami and started creating his own designs. Many of his pieces are sculptural in composition, relate to his work with wildlife, and feature elements made from folded paper mounted on structures to enhance their realism. His website is **berniepeyton.com**.

Andrea Russo
(b. 1981, Italian)

Andrea Russo has a background in law and a passion for art, which he expresses through his origami works. Rather than rely on traditional and conventional forms of origami, he prefers to create tessellations with geometric patterns and abstract sculptures using straight lines or curves, in an attempt to extract new forms and visual concepts. He has collaborated with designers and architects and has exhibited his work in museums and private galleries. Russo recently participated in a convention of Islamic Art, where he showcased paper tessellations that represented Islamic geometric patterns.

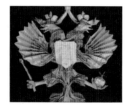

Victoria Serova
(b. 1969, Russian)

Victoria Serova is one of the few female origami folders to specialize in complex origami forms such as multi-legged insects and crustaceans. Her husband, Vladimir Serova, is also an origami artist, and together they have published several novels and exhibited their work in books and exhibitions throughout the world. Their joint website is **vs-origami.narod.ru**.

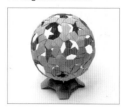

Heinz Strobl
(b. 1946, German)

Heinz Strobl is known for his development of two types of modular origami using strips of paper. In *Knotology*, the strips are knotted into flat pentagons layered on one another, and woven and plaited to make models that, like his *Snapology* figures, are stable without the use of glue or tape. In *Snapology*, which he developed later, strips are folded into polygonal prisms (the units or modules) that are joined using a second set of strips that snap them together, creating geometric forms. He has exhibited his works internationally.

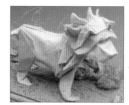

Richard Sweeney
(b. 1984, British)

Richard Sweeney studied sculpture and three-dimensional design in art school. As part of Sweeney's work with three-dimensional design, he manipulated paper by hand to create 3-D design models, many of which ultimately developed into sculptures. Combining hand-craft with computer-aided design and CNC (computer numerical control) manufacturing techniques, Sweeney seeks to maintain an experimental, hands-on approach, utilizing the properties of often mundane materials, such as paper, to discover unique sculptural forms. His website is **richardsweeney.co.uk**.

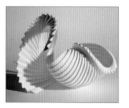

Nicolas Terry
(b. 1974, France)

A psychotherapist with a background in engineering and molecular chemistry, Nicolas Terry discovered origami as a child and in 2002 started creating his own designs, beginning with a snail. Since then, he has designed numerous forms, mostly of animals, given presentations and exhibited internationally. Terry has published books featuring his artwork, and has also worked to promote and publish the works of other internationally renowned folders. His website is **passion-origami.com**.

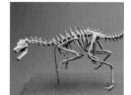

Hieu Tran Trung
(b. 1984, Vietnamese)

Hieu Tran Trung is a chemistry teacher living in Ho Chi Minh City, Vietnam. He has been folding since age four. Tran recently joined a growing group of Vietnamese origami folders and his work has been featured in several international exhibitions. Fascinated by dinosaurs, he specializes in constructing complex skeletons of various types of dinosaurs from multiple sheets of paper.

Florence Temko
(1921–2009, American)

Florence Temko was born in the United Kingdom and was a pioneer in spreading origami throughout both the UK and the United States, where she later lived. A prolific author on the subject of origami, she was a strong influence on origami beginners, many of whom went on to become renowned artists. Several of her designs, such as a family of penguins, are among the most popular with young folders.

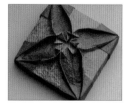

Arnold Tubis
(b. 1932, American)

Arnold Tubis taught physics at Purdue University for 40 years. Origami has been an avocation of his since the early 1960s and he has co-authored four books on the subject. Tubis has also published seven articles on the use of origami in mathematics education,

and served as a consultant to the *InCreasing Math* (origami math) project of the *Dramatic Results Organization* that operates in the public schools of Long Beach and Compton, CA. His works have been exhibited in the USA, Japan, Europe, and Israel.

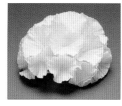

Polly Verity
(b. 1971, British)
Polly Verity is an artist based in Devon, England. She sculpts in a wide range of media and performs as a member of an experimental electronic band called "I," playing purpose-built and modified instruments. Her paper sculptures explore patterns and shadows and are complex and varied, from organic crumple forms to elaborate tessellations, often including curved folds. Her website is **polyscene.com**.

Makoto Yamaguchi
(b. 1944, Japanese)
Yamaguchi became a professional origami creator after working with the Nippon Origami Association. In 1989, he opened Gallery Origami House in Tokyo, a venue that showcases the works of origami folders. Yamaguchi encourages young creators to improve their models and exchange ideas and techniques with origami enthusiasts overseas. He travels extensively teaching the art of origami, and his passion has led to involvement with origami associations around the world. The Origami House website is **origamihouse.jp**.

Akira Yoshizawa
(1911–2005, Japanese)
Akira Yoshizawa is widely considered the father of modern origami art. The son of a farmer, he devoted his life to his art, living in poverty as he perfected his craft and developed thousands of new designs. He pioneered the now widely used technique of "wet-folding," which allows for delicate sculptural modeling of organic forms. In 1954, he was propelled to prominence by his book, *Atarashi Origami Geijutsu* (*New Origami Art*), which introduced a system of folding notation. The same year, he founded the International Origami Center in Tokyo and began holding origami exhibitions overseas, serving as a cultural ambassador for Japan. In his last decades Yoshizawa received worldwide recognition for his contributions; he wrote 17 more books on origami and in 1983 Emperor Hirohito awarded him the Order of the Rising Sun.

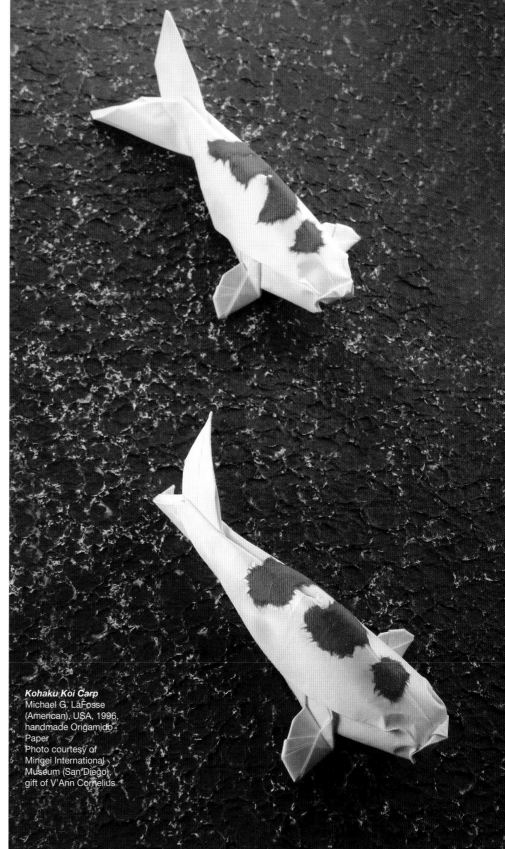

Kohaku Koi Carp
Michael G. LaFosse
(American), USA, 1996,
handmade Origamido
Paper
Photo courtesy of
Mingei International
Museum (San Diego),
gift of V'Ann Cornelius

ORIGAMI RESOURCE LIST

EXHIBITION CATALOGS ABOUT ORIGAMI

Hangar-7, Salzburg (ed.), *Masters of Origami at Hangar-7: The Art of Paperfolding, Ostfildern-Ruit*, Germany: Hatje Cantz Verlag, 2005

Mingei International Museum, *Origami Masterworks: Innovative Forms in the Art of Paperfolding*, San Diego: Mingei International Museum, 2003

ORIGAMI INSTRUCTIONAL BOOKS BY EXHIBITION ARTISTS

By Krystyna and Wojtek Burczyck

Twirl Kusudamas 1, Twirl Kusudamas 2, and Twirl Kusudamas 3, Zabierzów, Poland: self-published, 2008 (in Polish and English)

By Roman Diaz

Origami Essence, Passion Origami Publications, France, 2011 (Spanish and English)

Origami for Interpreters, Passion Origami Publications, France, 2006 (Spanish and English)

By Tomoko Fuse

Floral Origami Globes, Tokyo: Japan Publications Trading, 2007

Origami Quilts, Tokyo: Japan Publications Trading, 2001

Fabulous Origami Boxes, Tokyo: Japan Publications Trading, (9th edition) 1998

Quick and Easy Origami Boxes, Tokyo: Japan Publications Trading, 1994

Unit Origami: Multidimensional Transformation, Tokyo: Japan Publications Trading, 1990

By Eric Gjerde

Origami Tessellations, Awe-Inspiring Geometric Designs, Boca Raton/London/New York: A K Peters/CRC Press, 2008

By Paul Jackson

Folding Techniques for Designers: From Sheet to Form, London: Laurence King Publishers, 2011

Origami Toys: That Tumble, Fly and Spin, Layton, Utah: Gibbs Smith, 2010

Encyclopedia of Origami and Papercraft, Philadelphia: Running Press, 1991

By Eric Joisel

Eric Joisel, the Magician of Origami, Tokyo: Gallery Origami House, 2011

Eric Joisel, Passion Origami Publications, France, 2011 (French)

By Satoshi Kamiya

Challenge to Super Complex Origami, Tokyo: Gallery Origami House/Socym Corporation, 2010 (English and Japanese)

Works of Satoshi Kamiya 1995–2003 (by Makoto Yamaguchi), Tokyo: Gallery Origami House, 2005 (English and Japanese)

By Michael LaFosse and Richard Alexander

Michael LaFosse's Origami Butterflies, Tokyo/Rutland, Vermont/Singapore: Tuttle Publishing, 2013

Planes for Brains, Tokyo/Rutland, Vermont/Singapore: Tuttle Publishing, 2011

Trash Origami, Tokyo/Rutland, Vermont/Singapore: Tuttle Publishing, 2010

Origami Art, Tokyo/Rutland, Vermont/Singapore: Tuttle Publishing, 2008

Japanese Paper Crafting, Tokyo/Rutland, Vermont/Singapore: Tuttle Publishing, 2007

Advanced Origami, Tokyo/Rutland, Vermont/Singapore: Tuttle Publishing, 2005

By Robert J. Lang

Origami Design Secrets, Boca Raton/London/New York: A K Peters/CRC Press, 2011 (2nd Edition)

Sea Creatures in Origami (with John Montroll), New York: Dover Publications, 2011

Origami in Action, New York: St. Martin's Griffin, 1996

Origami Insects and Their Kin, New York: Dover Publications, 1995

Origami Animals (*Paper Animals* in the UK), Avenel, New Jersey: Crescent Books, 1992

Origami Sea Life (with John Montroll), New York: Dover Publications, 1990

Origami Zoo (with Stephen Weiss), New York: St. Martin's Griffin, 1989

The Complete Book of Origami, New York: Dover Publications, 1988

By Florence Temko

Origami Airplanes, Tokyo/Rutland, Vermont/Singapore: Tuttle Publishing, 2003

Origami for Beginners: The Creative World of Paper Folding, Tokyo/Rutland, Vermont/Singapore: Tuttle Publishing, 2001 (revised edition)

Origami Magic, New York: Scholastic, 1993

By Nicolas Terry

Passion Origami, Passion Origami Publications, France, 2005

Licence to Fold, Passion Origami Publications, France, 2008 (English and French)

By Vietnam Origami Group (Hieu Tran Trung, Giang Dinh)

50 Hours of Origami, Passion Origami Publications, France, 2011 (in English)

By Makoto Yamaguchi

Folding Japan with Origami in English, Tokyo: Natsumesha, 2005

Kusudama: Ball Origami, Tokyo: Japan Publications Trading, 1990

By Akira Yoshizawa

Origami Museum I: Animals (v. 1), Kamakura: Kamakura Shobo Publishing, 1987 (in English)

Sosaku Origami (Creative Origami), Tokyo: NHK, 1984 (in Japanese)

ORIGAMI AND MATHEMATICS, SCIENCE, TECHNOLOGY, AND EDUCATION

Demaine, Erik D. and O'Rourke, Joseph, *Geometric Folding Algorithms: Linkages, Origami, Polyhedra*, Cambridge, 2007

Hull, Thomas (ed.), *Origami3: Third International Meeting of Origami, Science, Mathematics and Education*, Boca Raton/London/New York: CRC Press, 2002

Hull, Thomas, *Project Origami*, Boca Raton/London/New York: A K Peters Ltd., 2006.

Lang, Robert J. (ed.), *Origami4: Fourth International Meeting of Origami, Science, Mathematics and Education*, Boca Raton/London/New York: CRC Press, 2009

Wang-Iverson, Patsy; Lang, Robert J.; and Yim, Mark (eds.), *Origami5: Fifth International Meeting of Origami, Science, Mathematics and Education*, Boca Raton/London/New York: CRC Press, 2011

ORIGAMI DOCUMENTARY DVD

Gould, Vanessa (director), *Between the Folds*, Green Fuse Films, NYC, 2010 (available through PBS.org)

ONLINE ORIGAMI RESOURCES

Origami Societies

origamiusa.org
The website of OrigamiUSA, the national organization based in New York City. Contains a calendar of origami events around the world and links to local and international origami societies.

britishorigami.info
The website of the British Origami Society, featuring The Lister List, a collection of scholarly articles about origami by British origami historian, David Lister.

origami.gr.jp
The website of the Japan Origami Academic Society, publisher of *Origami Tanteidan Magazine*, and one of two origami societies in Japan.

origami-noa.com
The website of the Nippon Origami Association, the other major origami association in Japan.

Other Online Resources

origamidatabase.com
An online database of over 40,000 entries, showing where models are diagrammed, which models are included in various books, pictures of folded models, and links to many origami websites.

origami-resource-center.com
A curated reference that provides information about the art of paper folding, links to diagrams, databases, book reviews, and ways to be a part of the paper folding community.

Many origami artists maintain their own websites and/or collections of their work on photo-sharing sites such as Flickr. URLs for such pages are given in the individual artists' descriptions, and many of them are readily found via various online search engines.

AFTERWORD

When art historian Meher McArthur first broached the idea of creating a major exhibition about the development and elevation of the Japanese cultural art of origami, one had to marvel at how a simple craft involving the folding of paper had become a vehicle for fine art and scientific breakthroughs as well. Here in the United States, the word *origami* is no longer a foreign word. As with Japanese foods like *sushi* and *teriyaki* and cultural activities like *taiko*, one rarely has to explain any of these terms in America.

As this book and the exhibition *Folding Paper: The Infinite Possibilities of Origami* make clear, it is origami's versatility that makes it so popular. Whether a part of Shinto rituals, a way to wrap gifts, or a method to teach children how to use their hands, origami lends itself to countless activities and uses. While most people would identify the meaning of a folded paper crane as a powerful image for peace, few of us could understand the computational origami that Dr. Robert J. Lang, exhibition advisor and *Folding Paper* artist, applied in his contribution to the design of the Eyeglass telescope. Origami structures now have the potential to forge new paths for space exploration.

The Japanese American National Museum has sought, since its inception in 1985, to promote understanding and appreciation of America's ethnic and cultural diversity by sharing the Japanese American experience. Our greatest projects have been when we, as an institution, learn to look at a familiar subject in a new way. An average of 20,000 students visit our museum annually, and most of them are taught by our dedicated volunteers how to fold a crane, a box or even a polo shirt. But this exhibition and catalogue has taken our knowledge of origami to a whole new level. It has fostered a profound respect for the artists, scientists and enthusiasts who have spent countless hours developing innovative ways of folding paper.

On behalf of the leadership, staff, volunteers and supporters of the Japanese American National Museum, I wanted to congratulate Meher McArthur and International Arts & Artists for the wonderful exhibition and the supporting catalogue. Our institution was proud to play a role in the development of *Folding Paper: The Infinite Possibilities of Origami* and our hope is that everyone will find it as compelling, thoughtful and outright fun as we do.

GORDON Y. YAMATE
Chairman of the Board
Japanese American National Museum

JAPANESE AMERICAN NATIONAL MUSEUM

The Japanese American National Museum is dedicated to fostering greater understanding and appreciation for America's ethnic and cultural diversity by sharing the stories of Americans of Japanese ancestry as an integral part of U.S. history and American culture. Since its incorporation in 1985, the National Museum has grown into an internationally recognized institution, presenting award-winning exhibitions, groundbreaking traveling exhibitions, educational public programs, innovative video documentaries and cutting-edge curriculum guides.

The Japanese American National Museum is located in the Little Tokyo Historic District of downtown Los Angeles and consists of three buildings joined by a pedestrian plaza totaling almost 120,000 square feet. Placed on the National Register of Historic Places in 1986, the Little Tokyo Historic District—including the National Museum's Historic Building, formerly the Nishi Hongwanji Buddhist Temple, built in 1925—is treasured as a vibrant cultural destination filled with museums, restaurants, and shopping.

The National Museum has addressed a broad spectrum of complex issues such as the benefits of diversity to communities; the impact of diversity on democracy; culture, identity, and the meaning of citizenship; and the impact of international relations and the importance of cross-cultural exchange and dialogue, especially between the U.S. and Japan. As an official affiliate of the Smithsonian Institution, the museum is known for producing ground-breaking exhibitions—such as *American's Concentration Camps* and *kip fulbeck: part asian, 100% hapa*—that have traveled nationally and internationally.

The National Museum's collection contains over 80,000 works—the world's largest concentration of Japanese American history and art objects. The National Museum has developed curriculum as a guide for teaching ethnic studies as part of its National School Project and provided innovative teacher training through its Multicultural Summer Institute for Educators in a dozen different states.

In 2010, while marking the National Museum's 25th anniversary, the museum was a recipient of the National Medal for Museum and Library Services, America's highest honor for museums and libraries across the country. The Institute for Museum and Library Services presented the National Medal to the museum in recognition of their "extraordinary civic, educational, economic, environmental, and social contributions." The Japanese American National Museum is only the second museum in California to receive the National Medal.

PEORIA RIVERFRONT MUSEUM

The Peoria Riverfront Museum is excited to bring *Folding Paper: The Infinite Possibilities of Origami* to central Illinois to engage visitors of all ages. This interdisciplinary exhibition is a superb fit to the museum's mission to inspire life-long learning in the areas of art, science, history and achievement as well as its commitment to present exhibits that explore creativity and innovation.

The PBS documentary film, *Between the Folds*, features fine artists and theoretical scientists who use their creative abilities to create amazing art forms by folding paper. The program captivated members of the museum's staff and board, who immediately realized that an exhibition about these individuals and how they have stretched the boundaries of origami would be an ideal one for the museum to host. At that time no such exhibition seemed to exist, and bringing together from around the world the material that was featured in the film was beyond the capabilities of the staff who were fully engaged in planning the opening of the Peoria Riverfront Museum in late 2012.

We were surprised and delighted when six months later one of our staff received a telephone call from International Arts & Artists, inviting us to consider hosting *Folding Paper*. This was exactly the exhibit we sought. We quickly embraced it and reserved the exhibition at the time of year when school group visitation is at its highest.

As one of the first exhibitions hosted by the Peoria Riverfront Museum, *Folding Paper* helps establish the dynamic tone of our exhibition schedule. Such an exhibition brings a broad range of world-class ideas to our visitors. We feel that the realization of our museum is like building a stage to the world and that *Folding Paper* will play well on that stage in Peoria!

The Peoria Riverfront Museum strives to find new ways to present programs to our visitors and new types of outreach programs. We pride ourselves on encouraging the kind of individual creativity that in turn supports the development of innovative ideas through team activity. Artistic creativity and the ability to see beyond the expected is clearly the basis of the works in *Folding Paper*, and we eagerly anticipate the enthusiastic reactions and creativity it will spark among young and old alike in our gallery.

It is an honor to be invited by the staff of International Arts & Artists to contribute an afterword to this catalogue. I applaud the standards of excellence the organization achieves in both its exhibition and publication programs.

JIM RICHERSON
President and CEO
Peoria Riverfront Museum

Architectural rendering of the Peoria Riverfront Museum, opened fall 2012.

ACKNOWLEDGMENTS

DAVID FURCHGOTT President, International Arts & Artists

Folding Paper: The Infinite Possibilities of Origami was conceived through the vision, ingenuity, and dedication of our guest curator, art historian Meher McArthur and exhibition advisor Dr. Robert J. Lang. We are all indebted to their years of research and efforts on behalf of *Folding Paper*. International Arts & Artists (IA&A) has been pleased to work with Meher and Robert to provide the public with the full benefit of their scholarship through the realization of this traveling exhibition and catalogue.

This is the first major exhibition to explore the rich tradition of paper folding in Japan and Europe, its evolution from children's craft to fine art, and its inventive applications in science, design, and the global peace movement. We express our deepest appreciation to the E. Rhodes & Leona B. Carpenter Foundation and the Japanese American National Museum, whose generous support enabled an exhibition of this scale and magnitude.

We wish to thank our venues for their overwhelming enthusiasm for the project and commitment to host the exhibition. At the Japanese American National Museum, Gordon Y. Yamate, chairman of the board, Lisa Sasaki, director of program development, Nikki Chang, collections manager, Tomi Yoshikawa, collections associate, and Clement Hanami, art director; at the Thorne-Sagendorph Art Gallery, Maureen Ahern, director; at the Leigh Yawkey Woodson Art Museum, Kathy Foley, director, and Andy McGivern, curator of exhibitions; at the Crocker Art Museum, Lial Jones, director, and Scott Shields, associate director and chief curator; at the Oregon Historical Society,

Kerry Tymchuk, executive director, and Marsha Matthews, director of public services; and at the Peoria Riverfront Museum, Jim Richerson, president and CEO, and Kristan McKinsey, vice president of collections and exhibitions.

Within IA&A, we wish to thank Margalit Monroe, Asian Art specialist and senior exhibitions manager, for her talent and dedication in conceptualizing and coordinating the exhibition and catalogue, as well as Elizabeth Wilson, assistant director of exhibitions and head registrar, for innumerable hours of planning and preparation. Simon Fong, IA&A Design Studio director and creator of this catalogue, deserves praise for his sophisticated design aesthetic and work ethic. Marlene Harrison, director of exhibitions, provided invaluable insight and guidance during the development of both the exhibition and catalogue. We also thank Dana Thompson, registrar, Sarah Nyamjom, registrar assistant, and Sanne Klinge, venue coordinator, for their efforts supporting the project. Margalit Monroe and Chris Sheppard were our editors and we thank them for their diligent review of catalogue content.

Our greatest debt of gratitude is owed to the *Folding Paper* artists, who receive additional thanks on page 96, and our many private and public lenders, whose gracious support made this exhibition possible.

For the Benefit of All,
David Furchgott
President
International Arts & Artists

ACKNOWLEDGMENTS

MEHER McARTHUR Exhibition Curator

The idea for this exhibition was born one night in April 2010 while I was watching Vanessa Gould's newly released documentary *Between the Folds*. The film spotlights the work of several major contemporary origami artists and demonstrates very clearly that origami has become an exciting new and international fine art form. I immediately knew that I wanted to curate an exhibition of this art and share it with as many people as possible. I thank Vanessa for opening my eyes to this extraordinary realm of art and science. I also thank my dear friend Cheryl Revkin for sharing the film with me and being so supportive of the exhibition.

That same night, I sent out an email to Robert J. Lang asking him what he thought of such an exhibition. He immediately responded with tremendous enthusiasm and helpful information on how to proceed. In the two years it has taken to create this exhibition, Robert has been the most invaluable advisor and partner in this project. With his vast scientific and mathematical knowledge, exceptional artistic talent and tireless generosity, he truly personifies the spirit of contemporary origami. I am deeply grateful to him for his guidance and assistance on this magical journey. Along the way, many people have shared our passion for the subject and generously contributed towards the development of the exhibition and this catalogue. In particular, I would like to thank Frank and Toshie Mosher, John and Neta Armagost, Setsuko Oka, Ron and Maureen Oban, Nelson and Priscilla Gibbs, Dawn Frazier, Dave and Mitsuko Felton, The Nichi Bei Fujin Kai, George and Marilyn Brumder, Ken and Erika Riley, Peggy Phelps, Louise Brinsley, Tony Michaelis and Frank San Juan, Cheryl Revkin, Maiya Pemberthy and one anonymous donor. Their support has been inspirational. I would also like to thank the E. Rhodes and Leona B. Carpenter Foundation for believing in this exhibition and generously supporting its national tour.

Much work has gone into putting this complex exhibition together and I would very much like to acknowledge the efforts and talents of the staff of International Arts & Artists, particularly David Furchgott and Marlene Harrison, who enthusiastically agreed to travel this exhibition, and Margalit Monroe, Elizabeth Wilson and Simon Fong, with whom work on the exhibition and catalogue has been both an education and a joy. Similarly, it has been a delight to work with the exceptional staff of the Japanese American National Museum in Los Angeles, in particular Lisa Sasaki, who has been a close colleague and partner in developing this exhibition since its inception. I would also like to thank members of OrigamiUSA, in particular, Jan Polish, who welcomed me to their 2010 convention to conduct research, Laura Rozenberg, who helped with my catalogue essay research, and Wendy Zeichner, who facilitated connections in Japan. I am also deeply grateful to Mrs. Kiyo Yoshizawa for granting us permission to use images of her late husband Akira Yoshizawa's work, and to Alain Joisel, who was equally as gracious about images of his brother Eric Joisel's work.

Finally, I would like to thank the Mingei International Museum and all of the artists, collectors and other lenders who have generously agreed to lend their works to this exhibition for four years. I very much appreciate their sacrifice and hope that it will be repaid to them one thousand fold.

Meher McArthur
Los Angeles, January 2012

ADDITIONAL THANKS

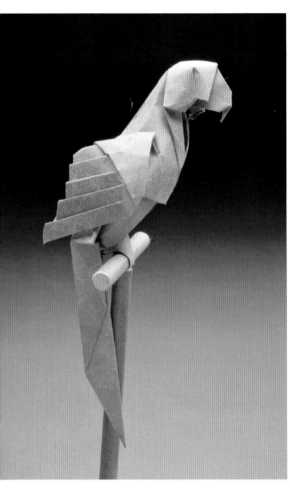

Parrot
Nicolas Terry,
(French), France, 2009,
Thai tissue, foil paper

Lisa Allen
Stéphanie Barbey
Jeremy Bigalke
Hani Buri
Tim Clark
Yves Clavel
Sham Dixit
Annie Dugger
Mitchell Eaton
Kristi Ehrig-Burgess
Peter Engel
Amethyst Gillis
Bob Gillis
Vanessa Gould
Rainer Hoffman
Graham Howe
Elise Huffman
Toni L. Hunter
Takayuki Ishii
Misako Ito
Sarah Jaeger
Ruthie Kitagawa
Christine Knoke
Hirokazu Kosaka
Duks Koschitz
Kaori Kuribayashi-Shigetomi
Monica Leigh
Jun Maekawa
Ryoko Matsuba
Jacqueline McBride
Jenée Misraje
Koryo Miura

Silke Schroeder
Vicky K. Murakami-Tsuda
Yoshihiro Nihei
Toru Nishiyama
Keith Nowak
Gary Ono
Jorge Pardo
Koji Sakai
Tim Schierwater
Rob Sidner
Norman Sugimoto
Carol Tanita
Naohiko Tsujimoto
Michio Valian
Lynn Yamasaki
Zhang You

ARTIST LIST

John Blackman
Krystyna Burczyk
Wojtek Burczyk
Brian Chan
Joel Cooper
Erik Demaine
Martin Demaine
Roman Diaz
Giang Dinh
Christine Edison
Vincent Floderer
Tomoko Fuse
Eric Gjerde

Miri Golan
Koshiro Hatori
David Huffman
Tom Hull
Roy Iwaki
Paul Jackson
Eric Joisel
Satoshi Kamiya
Miyuki Kawamura
Hideo Komatsu
Goran Konjevod
Daniel Kwan
Michael G. LaFosse
Robert J. Lang
Sipho Mabona
Linda Tomoko Mihara
Jeannine Mosely
Paulo Mulatinho
Jared Needle
Bernie Peyton
Andrea Russo
Victoria Serova
Heinz Strobl
Richard Sweeney
Florence Temko
Nicholas Terry
Tran Trung Hieu
Arnold Tubis
Herman Van Goubergen
Polly Verity
Makoto Yamaguchi
Akira Yoshizawa

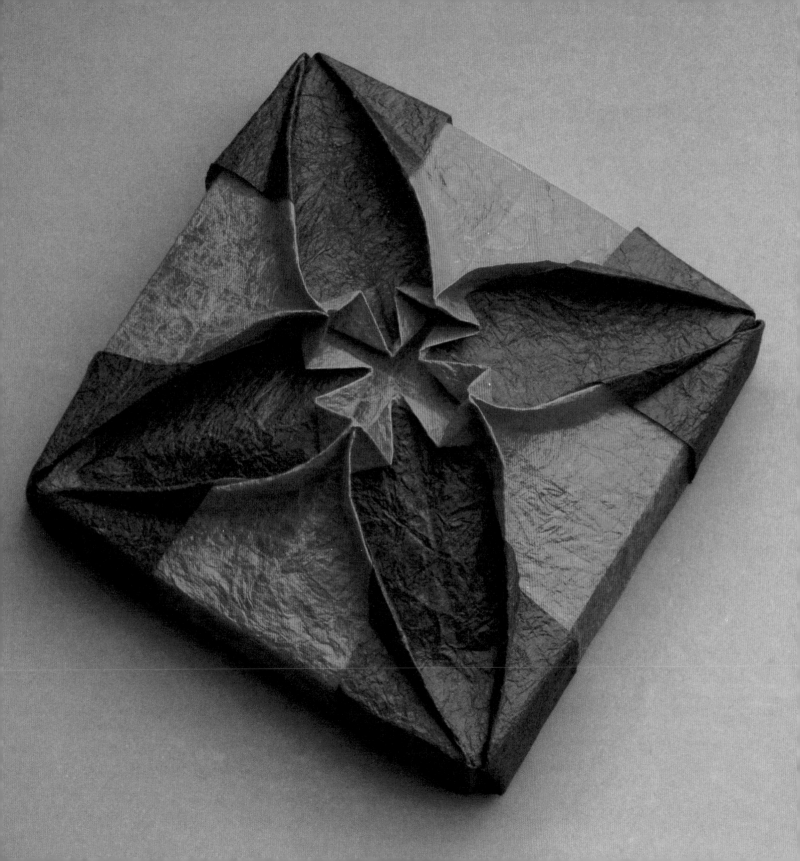